THE PAINTER'S PROBLEM BOOK

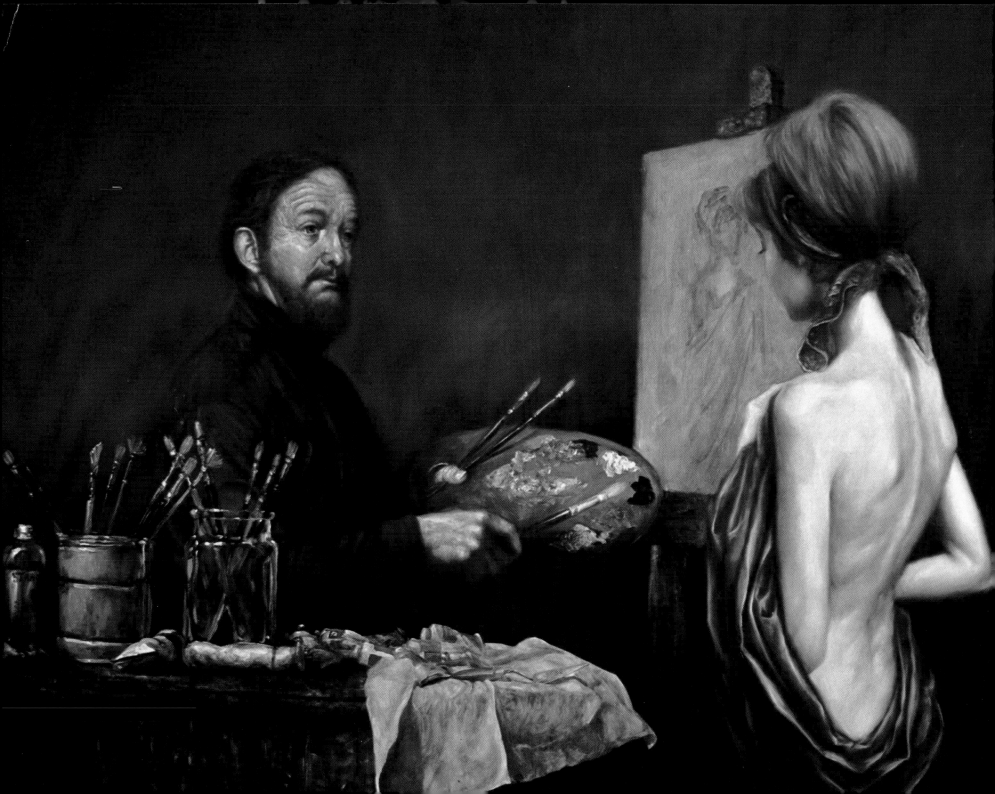

Artist and Model, oil on Masonite, 31-1/4'' x 42''. This painting incorporates almost all the elements in this book — wood, glass, fabrics, metal, fur, etc. I painted everything individually first and then did a great deal of blending so the painting would work as a whole. The most important thing, however, was to determine the various relationships within the painting, both in terms of color and of design. Collection Mr. and Mrs. Robert Genin.

THE PAINTER'S PROBLEM BOOK
20 Problem Subjects and How to Paint Them

BY **JOSEPH DAWLEY** AS TOLD TO GLORIA DAWLEY

WATSON-GUPTILL PUBLICATIONS • NEW YORK

PITMAN PUBLISHING • LONDON

We dedicate this book to two most cooperative and
understanding children — our daughters, Cynthia and Catherine.

First published 1973 in the United States and Canada by Watson-Guptill Publications,
a division of Billboard Publications, Inc.,
165 West 46 Street, New York, N. Y.

Published simultaneously in Great Britain by Sir Isaac Pitman & Sons Ltd.,
39 Parker Street, Kingsway, London WC2B 5PB

Manufactured in Japan

Library of Congress Cataloging in Publication Data
Dawley, Joseph.
 The Painter's Problem Book.
 1. Painting—Technique. 2. Artists' materials.
I. Dawley, Gloria. II. Title.
ND1473.D39 751.4'5 72-12704
ISBN 0-8230-3515-8

First Printing, 1973

Our thanks to those on the technical end of publishing this book — their talent and enthusiasm are much appreciated.

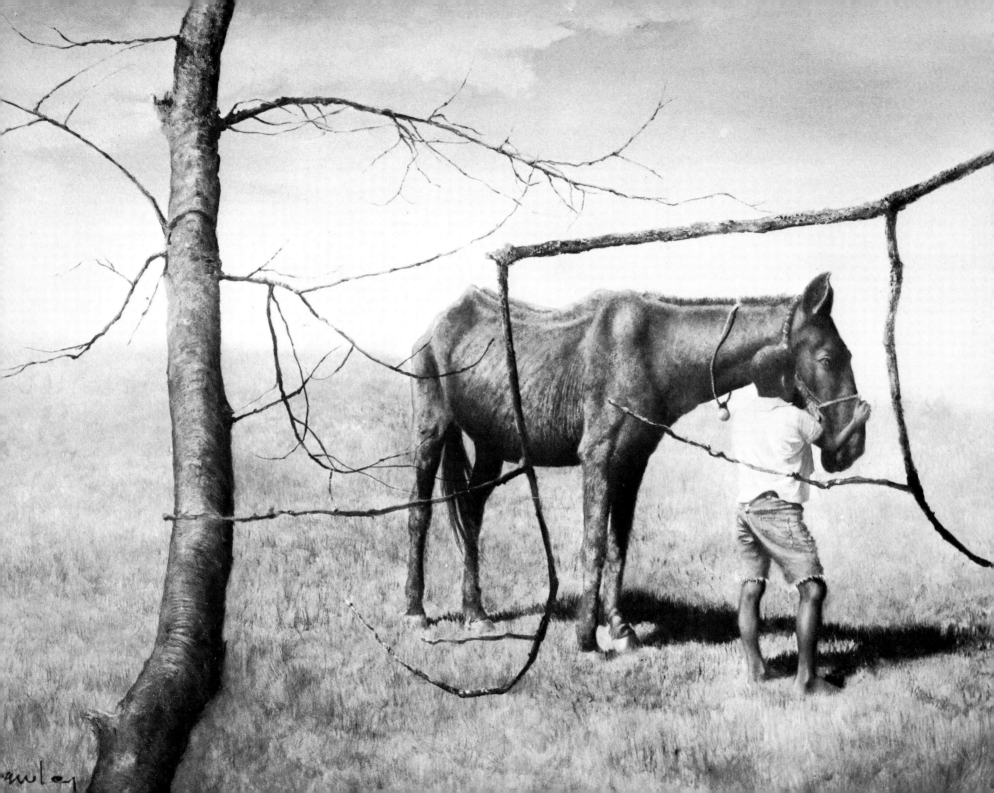

CONTENTS

Boy with the Mule, oil on board. The mule in this painting has so much pizazz in his old, worn body that I spent more than twice as much time on the mule than on the rest of the painting. His body displays some of the same painting characteristics as the worn leather shown in Demonstration 15. Collection Dr. Myron Shapiro.

Gigi Reading, oil on Masonite, 12-1/2" x 17". This portrait of my wife (my favorite model) is an example of both shiny and frilly fabrics. Her yellow skirt was painted with cadmium yellow, Mars yellow, yellow ochre, cobalt yellow, and raw umber. Collection Mr. and Mrs. Milton Gelman.

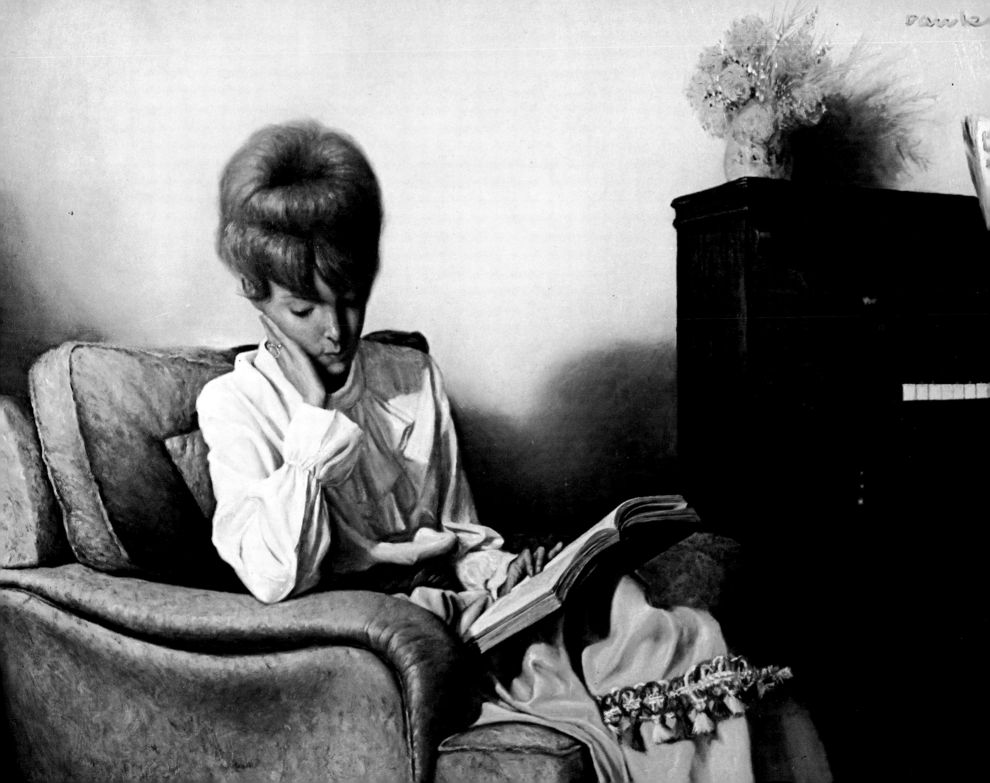

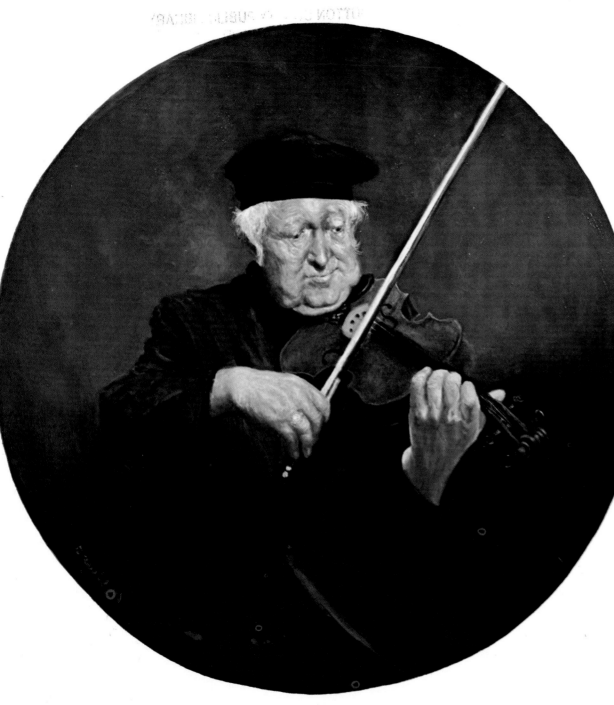

Man with Violin (Left), oil on Masonite, 17" x 15". I find that some paintings are enhanced by a circular or an oval shape. In this painting the circle brings all the action together and adds a touch of the dramatic. The bow seems to slice through the background like a knife cutting an apple because of its contrasting linear form. Collection Mr. and Mrs. John Davis.

The Turtle Race (Right), oil on Masonite, 23-1/2" x 31-1/2". Obviously, the four seated gentlemen and the bartender have each picked a turtle and probably have a little currency riding on his ability to cross the finish line first. This painting shows an effective way to use wood and glass in a finished composition. Collection Mr. and Mrs. Hy Hait.

10

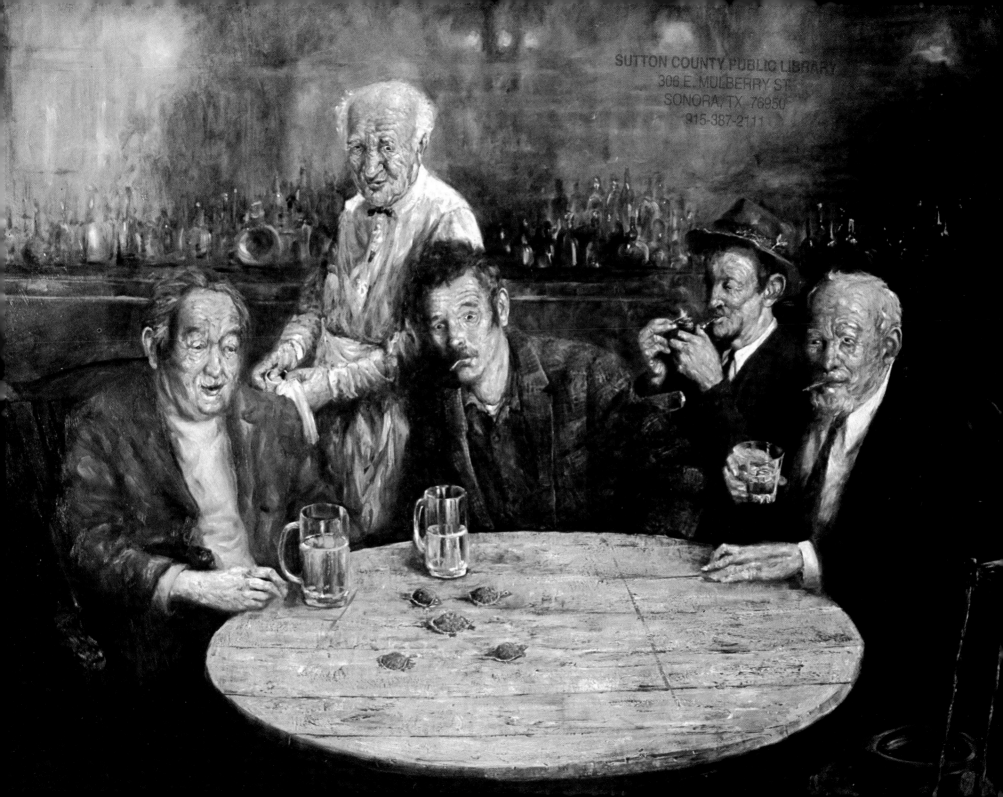

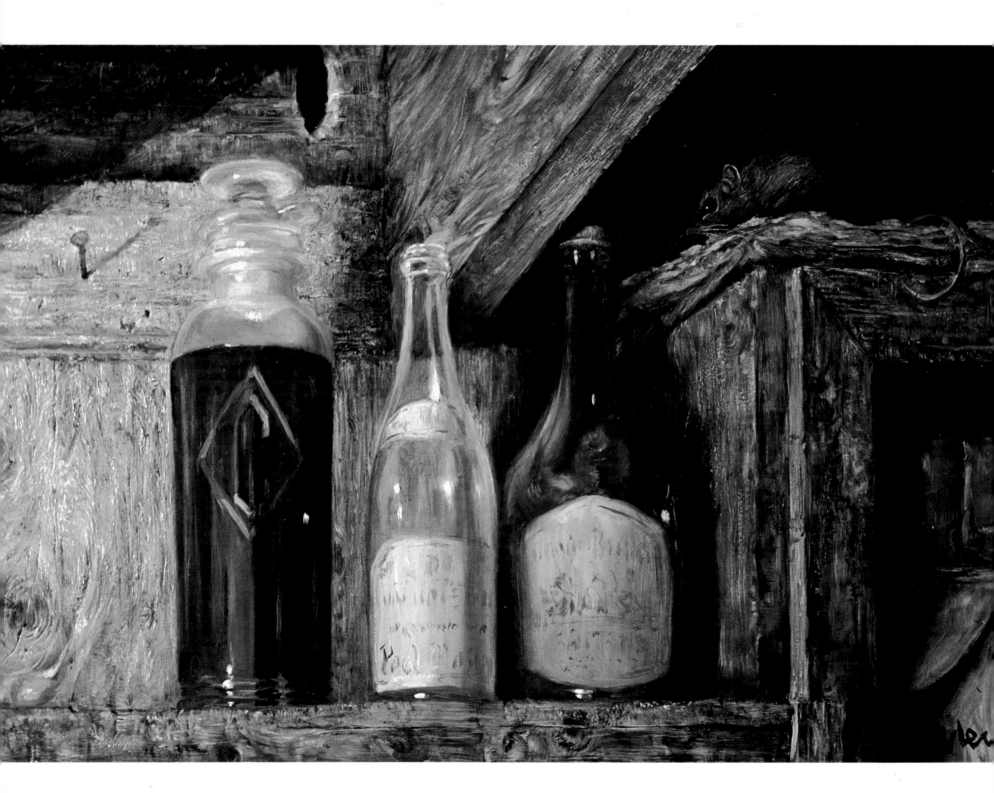

In the Attic (Left), oil on Masonite, 10'' x 14-1/2''. This painting concentrates on the various qualities of wood and glass. It's not really a "still" life, however, because your attention will ultimately be drawn to the mouse crawling on top of the old paper on the shelf. Collection of the artist.

Reflection (Right), oil on Masonite, 17-1/2'' x 13-1/2''. The silver urn used in Demonstration 3 and the china cup in Demonstration 19 are combined with other elements in this still life. The main interest, however, is in the girl's face reflected in the silver. Collection Mr. and Mrs. David Godvin.

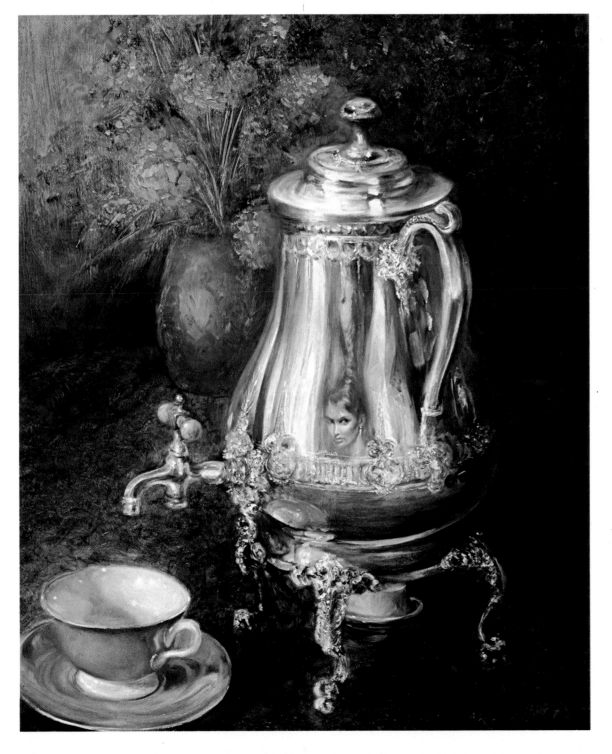

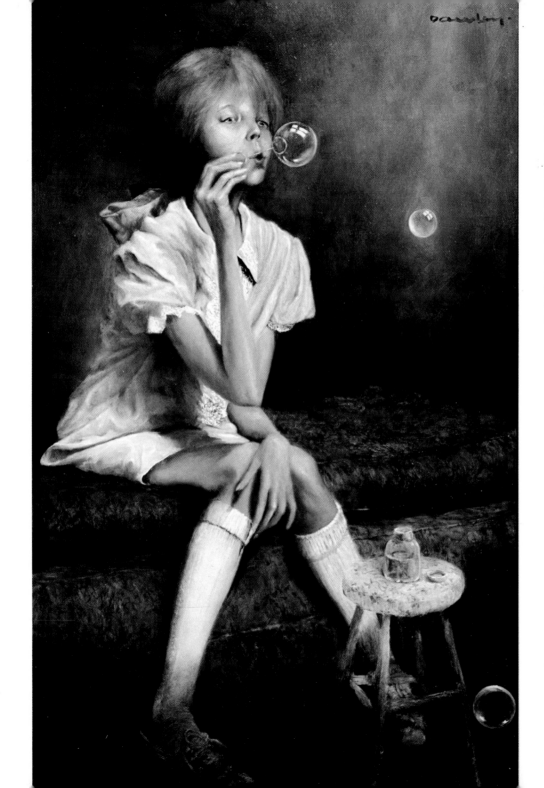

Girl Blowing Bubbles (Left), oil on Masonite, 25'' x 15''. Joshua Reynolds supposedly said that it was virtually impossible to paint a portrait with predominately blue surroundings, and Gainsborough replied by painting "Blue Boy." Although I don't use the idea very often, in a few cases it works. The girl even has some blue in the skin tone, which I never do unless there's a great deal of blue in the rest of the painting. The soap bubbles are painted in the same manner as glass. Collection of the artist.

Watching the Goldfish (Right), oil on Masonite, 17'' x 25''. Lacy fabric, glass, and reflections on a tabletop are all included in this painting. It also shows how objects floating in water can be rendered. Note that the softened edges contribute to the feeling of weightlessness. Collection of the artist.

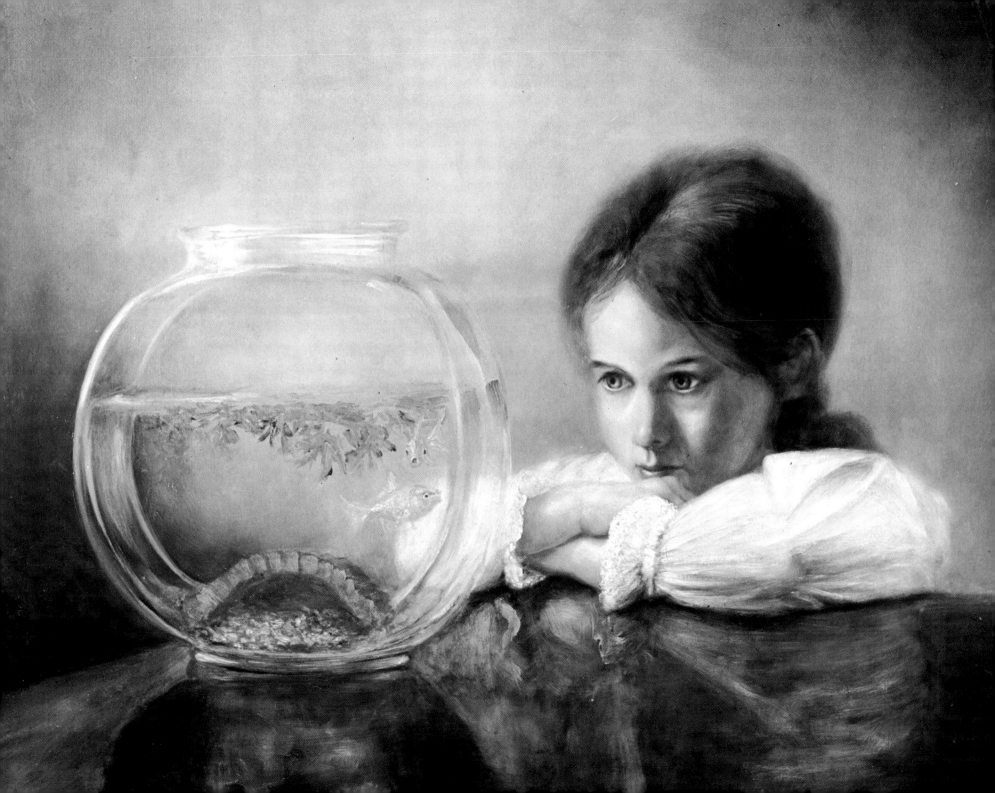

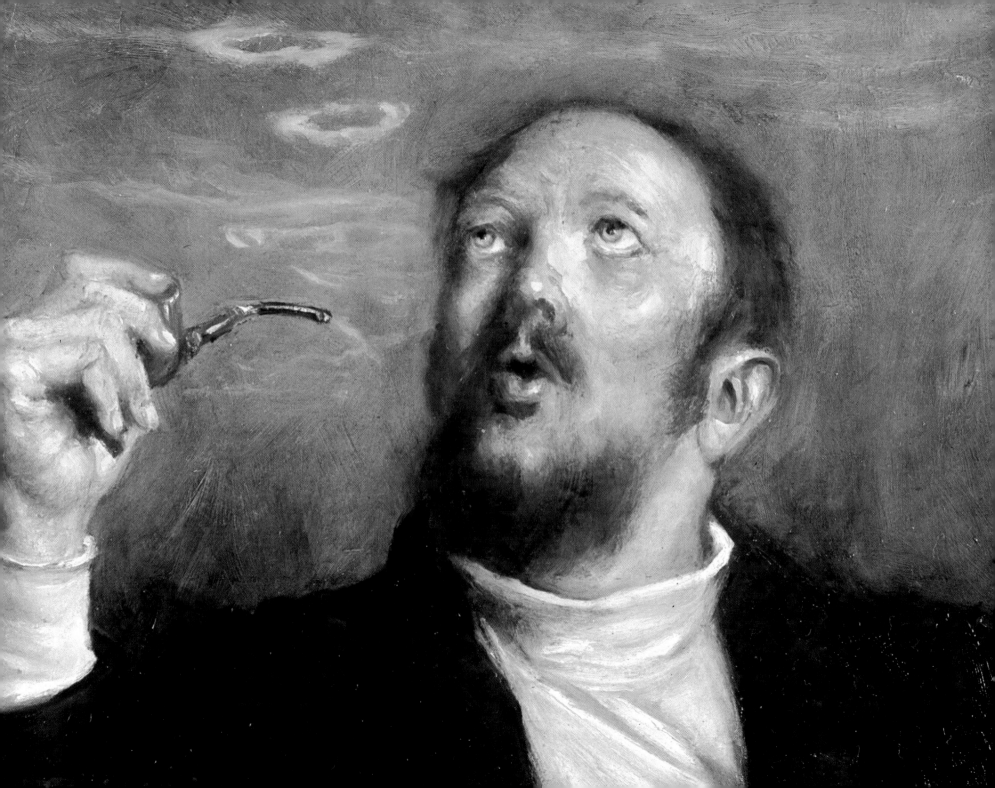

INTRODUCTION

Smoke Rings, oil on Masonite, 7'' x 8-1/2''. I painted the smoke by underpainting the background with raw umber and white and then glazing raw umber over the top. While the glaze was still wet, I brushed in the smoke rings with ivory black-and-white gray, using a flat, soft sable brush. Collection Mr. and Mrs. Malcolm Mason.

The texture of a fabric, a translucent object, the reflection of light on a surface — all these can be difficult problems for the oil painter. In the pursuit of my own specialty, character painting, I find it necessary to deal with a large variety of these problem subjects, which makes me all too aware of the potential disaster of not being technically well rounded. It's my hope that this book will provide the reader with the techniques necessary to paint a wide variety of items, from fabrics and jewelry to wood, potatoes, and pottery. These items might form the focus of a painting, a still life for example, or they might be props in a portrait painting. In either case, it's important to be able to render all areas of the painting equally well. Although this book can't possibly include all the subjects you might want to paint, you'll find that you'll be able to apply techniques learned to an infinite number of other things: if you can paint silver then you can paint gold; a wine glass can be modified to become a windowpane; the technique used to paint a silver urn also applies to a mirror, and so on.

In the firm belief that "problem subjects" need not become stumbling blocks but, rather, that they can be used to enhance a painting, I invite you to pick up your paintbrush and accompany me as I demonstrate just how to approach 20 of the most common of these subjects in the pages that follow.

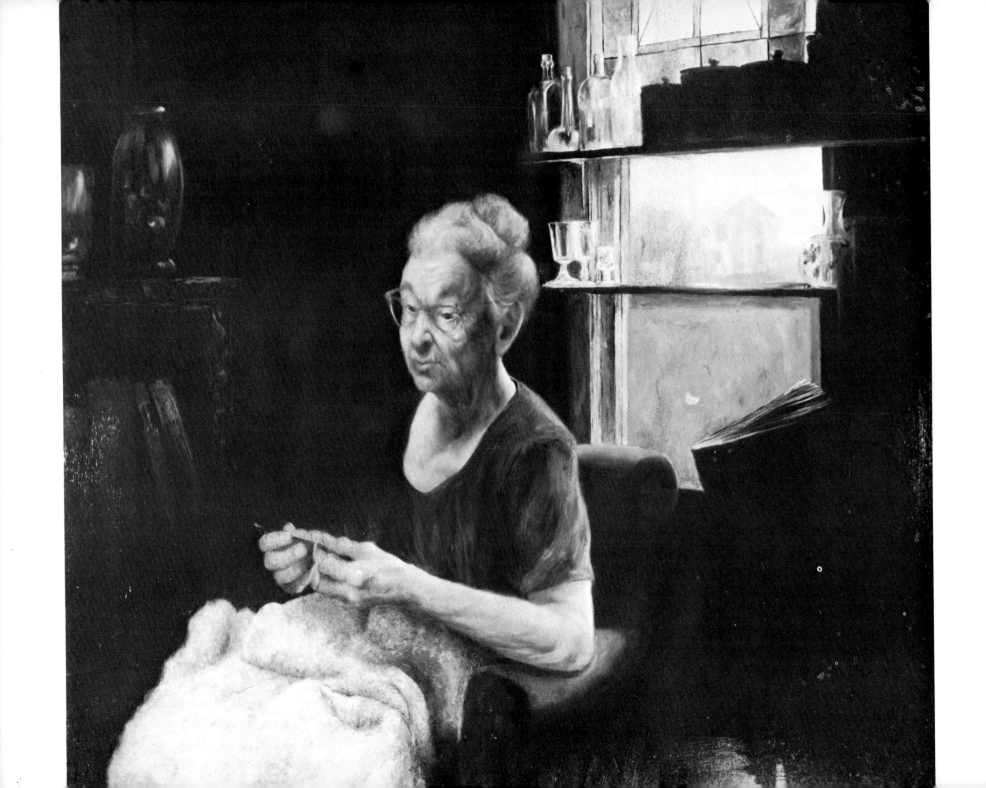

MATERIALS
AND METHODS

By the Window, oil on Masonite, 26" x 26". The light from the window shows through the glasses on the ledge, giving a softness to all parts of the painting. The old lady's knitting is a good example of using rough-textured fabrics. Collection Dr. and Mrs. R. Hartkopf.

Like most artists, I have certain materials, colors, and painting methods that I prefer to use. I believe it would be helpful to see what I work with and to define some of the techniques I'll use throughout the demonstrations.

PAINTS AND PALETTES

These are the colors I like to use, plus some notes on their important characteristics.

Alizarin crimson. A transparent, cool red. I use it sparingly for skin tones. I also like genuine rose madder, which is a bit more delicate.

Burnt sienna. One of the colors I can't do without. It's a red-brown which mixes well with other colors, is great for skin tones, and is a good drier.

Burnt umber. A warm brown color. I only use it on occasion for glazing.

Cadmium red. A bright, opaque red which comes in a variety of shades, and can be good for skin tones. I seldom use the lightest shade, but I use the medium and deepest shades quite often.

Cadmium yellow. A bright, opaque color that also comes in a variety of shades and is very useful in painting gold objects or candlelight. It can also be used for a bright green when mixed with black or blue, or for a muted green when mixed with raw umber.

Cadmium orange. A bright, opaque orange that I use only in painting an orange.

Cerulean blue. A bright, opaque blue that I use mostly in painting pottery or in a sky.

Cobalt blue. A bright but more transparent blue that mixes well with other colors.

Cobalt violet. A clear, bright violet or purple. I use it for spots in paintings that need a little color and often for shadows in the folds of a drape.

Cobalt yellow (aureolin). One of my favorites. It's a bright, transparent color which is excellent for glazes and dries quickly. I sometimes mix it with cadmium red deep for a glaze in skin tones.

Flake white. A basic lead carbonate and a good all-around white. Ground in linseed oil,

it's the best white for priming canvases and panels, and it's good for underpainting because of it's elasticity.

Ivory black. A cool black that's excellent for everything including skin tones. Note that you should never paint another color over pure ivory black or lamp black; cracking may occur.

Lamp black. A bit warmer than ivory black, but can again be used for anything. When mixed with Mars yellow (or yellow ochre) and burnt sienna it makes a beautiful brown.

Mars yellow. A muted yellow that can be substituted for yellow ochre, and it's quite good for skin tones.

Oxide of chromium. A beautiful, opaque, pastel green. I find it complements whatever other colors it's used with.

Phthalocyanine blue. A very strong, transparent, slightly greenish-blue color. I use very little due to it's great strength (for example, 40 parts white to one part phthalo blue gives the color of the sky on a clear sunny day).

Raw sienna. An earthy yellow that's darker than yellow ochre and more translucent. It's good for skin tone, painting wood, and for tinting and glazing.

Raw umber. A very soft, warm, neutral brown that makes a good, blackish glazing color when mixed with ultramarine blue. A raw umber I also like is an English pigment put out by Winsor & Newton. It's a more greenish, cool color and I sometimes mix it with white and a tiny bit of ultramarine blue to get a gray. I also use it for skin tones.

Titanium white. An opaque white with great covering power, but it's more brittle than flake white when painting on canvas.

Ultramarine blue. A beautiful, semi-transparent blue that mixes well with other colors. It's a great glaze when mixed with raw umber and it's a good color for tinting or wet into wet painting.

Underpainting white. A thick and pasty, quick drying titanium white. It's great for scumbling or when fast drying is essential.

Venetian red. An earth red that's much brighter than burnt sienna and is one of my favorite skin tone colors. It mixes well with other colors and is good for underpainting.

Viridian green. A transparent emerald color that's good for glazing. When mixed with yellows it makes bright green colors and when mixed with raw umber it makes a more somber color.

Yellow ochre. An earth yellow which I use more of than any other color except white. It's good for mixing skin tones, gold objects, and for mixing with other colors to make shades of browns, greens, and somber oranges.

MONOTONE PALETTE

Steps 1 and 2 of each of the following 20 demonstrations are monotone oil exercises which appear as black and white in this book, although I'll actually be doing them in raw umber and white. My favorite white is titanium. I always put more oil paint than I need

on my palette and suggest you do the same. It's better to throw away a little paint than to be annoyed by having to mix more. I lay out a five-tone range on the palette. Tone 0 is pure white; Tone 1 is about 95% white and 5% raw umber; Tone 2 is about 90% white and 10% raw umber; Tone 3 is about 75% white, 25% raw umber; Tone 4 is pure raw umber from the tube.

I'll refer to these Tones by their assigned numbers throughout my explanations of the first two steps of each demonstration and wherever else I require them. Note that raw umbers differ in their covering power. You'll have to use twice as much as indicated above with some brands to produce the desired tones. The percentages are only approximations for the reader's convenience and you're urged to rely on common sense.

The monotone palette, no matter what low-keyed colors make up the desired tones, is actually a step in painting. The colors used for the tones depend on the finished color of the object being painted. For example, phthalo (phthalocyanine) blue was added to the monotone palette for the demonstration on silver, which gives me a good solid base to build on.

SKIN TONE PALETTE

There are several demonstrations in this book that include parts of the figure. Because skin tone isn't the focus of any of the demonstrations, I won't fully discuss the painting methods involved. An intricate explanation of these techniques can be found in my previous book,

Character Studies in Oil. I feel, however, that it's helpful to note the colors I like to use. My basic skin tone palette consists of white, Venetian red, yellow ochre, Winsor & Newton raw umber, and raw sienna. I combine the raw umber with ultramarine blue to get a type of black. I use burnt sienna and white, along with a black-and-white gray, as the painting develops. My favorite highlight color is a mixture of yellow ochre, white, and ivory black, which produces a cool highlight on a warm skin tone.

BRUSHES

I use several types of sable or bristle brushes to achieve many different effects in my paintings:

Sable brushes. Produce a smooth, rather delicate stroke. I always use a flat, soft, short-haired brush in widths ranging from 1/8" to 1". I use a #2 or #3 sable watercolor brush, which points well at the end, for small detail work. I never use the long-haired sables designed for detail work in oils, because they aren't of a good quality. Occasionally I'll use a sable fan brush for blending.

Bristle brushes. Produce the rougher effect necessary for textured subjects. I use natural curve white bristle brushes. They are flat, short haired, and I use all sizes up to 3/4".

PALETTE AND KNIVES

I prefer 12 x 16" paper tear-away palettes. They're easily handled and discarded, which is

Monotone Palette. Here's my palette that I'll be using for the 20 demonstrations that follow. I begin with pure titanium white on the top row, which I'll call Tone 0 from now on. As I move toward the right, my Tones — called Tones 1, 2, and 3 — darken until I arrive at Tone 4 which is pure raw umber.

important to me because I use three palettes simultaneously. One palette is for skin tones, another for background, and a third for painting the extras.

The only time I use a palette knife is when I'm mixing colors on my palette. I tend to use any knife that's handy, for particular palette knife characteristics aren't important to me.

TURPENTINE AND RAGS

I've found artist's rectified turpentine an unnecessary expense, so I use a good grade of gum turpentine that I test to make sure it's not yellowed. I use two jars of turpentine for cleaning my brushes: one is exclusively for a rinsing process to remove excess paint; the other, the cleaner jar, is for the final soaking and cleaning. I wipe the brushes carefully to remove all residue, then place them bristles up in a large-mouthed jar that I keep close at hand.

I use anything soft for rags — socks, sheets, underwear, etc. — and prefer pieces about 18" square. When a rag gets too dirty I discard it immediately.

PAINTING SURFACES

There are two types of surfaces that I like to work on, masonite and canvas, and here are some of their characteristics:

Masonite. I prefer masonite as a painting surface for most situations. It's easy to work on, holds up against the effects of weather, is impervious to bumps or knocks that might damage canvas, and can be readily cut to fit the design of the painting.

I always buy 1/8" untempered boards in 4' x 8' sheets. I cut these into thirds for ease of storing.

My first step is to apply two thin coats of gesso to the rough back of the board. I then set it aside to dry for six weeks in the warmest, dryest room possible. After this I wipe a mixture of flake white and turpentine — it should be of a runny consistancy — onto the smooth surface of the board with a clean cloth, leaving a very thin coating. The board should be set aside again for at least six weeks to dry.

Again I take flake white thinned with turpentine to a medium consistancy and apply it to the surface with a large, soft brush. When this has dried to the touch I repeat the procedure twice more, and I'm ready to begin painting.

Underpainting white may be applied to the board instead of flake white with one big caution attached: never paint flake white over underpainting white; cracking may result. However, underpainting white may be used over flake white with no problems at all.

Canvas. I occasionally use stretched canvas instead of Masonite when I'm working on a large figure study that requires a "brushy" approach. The rougher surface of the canvas helps produce this. I prefer to do all the stretching and preparing myself; I buy only top grade Belgium linen of a smooth or medium texture.

I join the stretcher strips together, squaring the corners as I do so. I then place the frame on top of the linen to cut it, leaving very generous overlaps. I wrap the canvas around the frame and secure it on one of the long sides with a tack placed in the middle of the overlap. I normally use #8 blued cut tacks with large heads. I tack again on the opposite side, pulling the linen fairly taut with canvas pliers especially designed for this purpose. I secure the short sides in the same way. I then proceed working around the frame, stretching the linen tightly as I tack. The corners are folded and tacked for neatness.

Next I prepare rabbit-skin glue according to the directions on the package. This is applied to the surface of the linen with a sponge; it shrinks and tightens the canvas, producing an extra degree of firmness. When this is completely dry I sand the surface lightly and apply a second coat. To seal off the back I brush on a 5% or 6% formaldehyde solution.

The next step is to rub flake white into the surface with a turpentine-soaked cloth. I let this dry and then with a spatula apply 3 to 5 coats of flake white straight from the tube, smoothing each one as I go.

Painting Medium. I make my own medium using a formula of one part Damar varnish (5 lb. cut), one part stand oil, five parts gum turpentine, and one drop of cobalt drier per every two ounces of medium. Occasionally I use a heavier mixture that's identical to the one above except it contains four parts gum turpentine.

The only time I use turpentine to thin my paint is when I'm working with the monotone palette for the beginning steps. After this I use the paints as they come from the tube. I don't use painting medium with the paints until I start overpainting; when the painting is completely dry I paint the medium over the entire surface and also use it along with the paints. If I become involved in the heavy reworking of an area, I use the heavier painting medium.

PAINTING METHODS

These are the painting methods I use throughout the demonstrations:

Alla prima. Applying wet paint on a field of other wet paint. This is the basic form of painting for everyone. Some painters like to start and finish every painting this way, with no overpainting or underpainting. If the paint is applied thickly, it's called *impasto.*

Glazing. A step after the impasto underpainting is dry. A glaze is a transparent layer of color, usually thinned with painting medium. My method is to first spread my painting medium over the entire surface of the dry paint. Then, dipping a soft sable into the medium and then into the transparent or semi-transparent color, I brush it over the part of the painting I choose to glaze. This produces a translucent, bright effect.

Tinting. A process similar to glazing, but in this case I use a thin layer of opaque color to modify an underlying layer of dry color. Although it covers the underlying area with an opaque mixture of paint, a tint is thin enough to let the underpainting show through ever so slightly. This is done for example in skin tone where a portion of the face may be a mixture of flake white, yellow ochre, and Venetian red. I might take my painting medium and thin down a mixture of burnt sienna and white and apply it thinly over the top of the area.

Brushy. My term for a painting rich with visible flowing brushstrokes. I often use a brushy effect for objects that have obvious texture.

Underpainting. The first coat (or coats) of paint, which is meant to be improved upon with subsequent layers of paint after the underpainting is dry. An example of this would be a raw umber or white, preliminary indications of lights and darks, later painted over with ivory black and raw sienna — the overpainting.

Overpainting. Can be a glaze, tint, or scumble. Overpainting differs from glazing in that it covers the underpainting completely, leaving no trace of the paint underneath, while glazing allows the paint beneath to show through in a translucent way. Tinting falls somewhere between glazing and overpainting.

Scumbling. Dragging paint over the top of an already partially dry surface of paint. This can be done in an impasto or in a glazing or tinting manner. I do it with a soft sable brush and never allow it to dip into the underlying color enough to "pull" or loosen the lower layers of paint from the surface. This method produces a unique effect as the paint glides over the sticky surface of previously applied paint: the scumble mixes partially with the underlying color; it also rides on top of it.

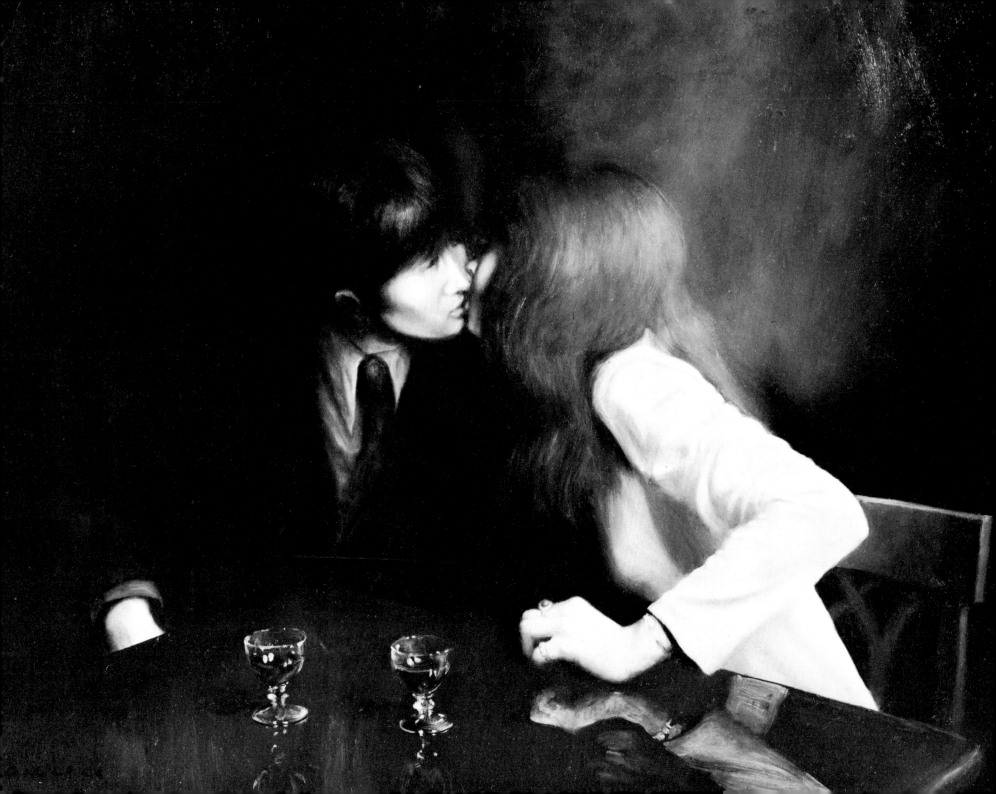

DEMONSTRATION 1
GLASS

The Kiss, oil on Masonite, 15" x 20". The glasses of wine on the table help set the romantic mood of the painting. Collection Mr. and Mrs. Morton Goldman.

To paint glass well, you have to get over two rather large stumbling blocks: drawing the glass accurately and rendering its translucent quality. Most subjects in this book allow some leeway in drawing, but a glass doesn't allow even this minimal freedom. A poorly drawn glass will be ludicrous no matter how well you render its translucency.

Your only touch of freedom comes in the application of minor color reflections, which leads us to your second problem. The ability to recreate translucency is very important if you hope to produce the essence of glass. To achieve the translucency seen in this demonstration, apply your paint thinly to allow for a great deal of delicate blending. You can be much "brushier" — which means using thicker paint — and still produce a well-rendered glass, but you will not be able to achieve a high degree of translucency.

I've tried to present two situations in one in this demonstration. The glass is seen against both dark and light, which should enable you to handle your subject against any background. In reality, this glass is sitting on a white piece of paper. However, the white seen through the glass becomes an off-white, which I've darkened even further to set off the highlights of the glass. Because I've darkened the off-white paper seen through the glass, I also had to soften the rest of the paper to an off-white to tie in the glass more tightly with the surroundings.

One further observation about glass: shadows cast from glass are often soft because no opaque mass exists to block rays of light.

Glass: Step 1. My sole aim in Step 1 is to capture shape and proportion accurately. Since the glass is sitting on a white base and I'm painting on a white surface, I leave the lower area of the canvas unpainted for now and begin by indicating the dark background with Tone 4 thinned with turpentine. I lay this in roughly as a rectangular shape; it's more practical to lay in this dark area first and then paint the glass on top of it, rather than draw the glass first and add the dark background afterward.

Next, I use Tone 0 to draw in the upper outlines of the glass on top of Tone 4. I prepare a thicker white to show prominent reflections and highlights, such as those found on the rim and in the bowl. I then draw the lower half of the glass on the canvas with thinned Tone 2. Again, I indicate major reflections — such as those on the stem and base — by using thicker paint.

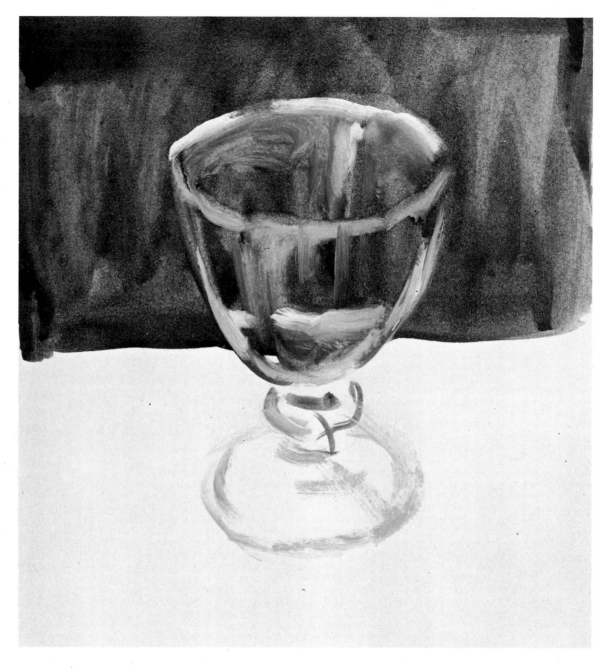

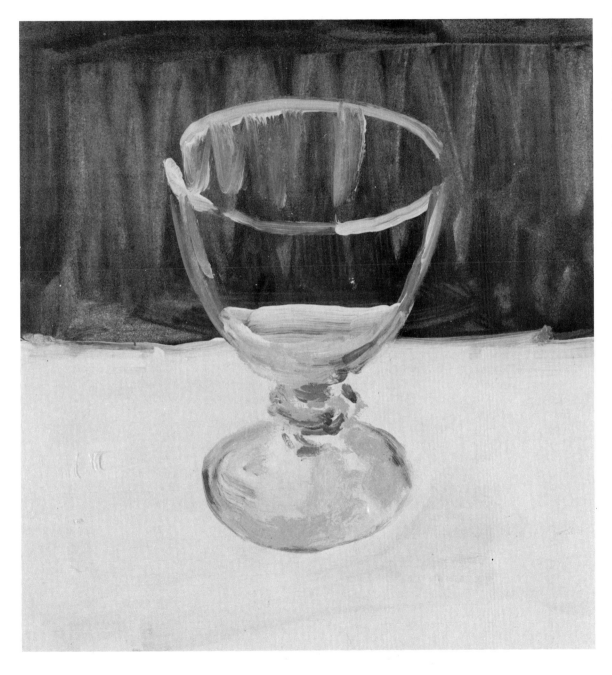

Glass: Step 2. I continually check my drawing so I don't disturb my guidelines as I proceed to fill the canvas with the approximate values. I use Tone 0 for the paper beneath the glass and also fill in the large reflection of the paper in the bottom of the bowl with this tone. Because I'm painting into the raw umber background, this reflection won't appear pure white.

I paint the stem and base of the glass in tones of off-white rather than pure white, so the final touches of white will really glitter by contrast. I use Tone 1 for the light areas such as in the base. For the areas in both the stem and the base that appear a bit darker, I use Tone 2. The small, darkest reflections — such as those on the right side of the stem and on the perimeter of the base — are done with Tone 4. For the very lightest spots in these two areas I use Tone 0 and a #2 watercolor brush. Precision counts when you're painting glass, and I find it necessary to use a small brush to capture the minute but important value changes.

Glass: Step 3. I add ultramarine blue and yellow ochre to my palette. Accuracy in painting all the reflections and highlights is of the utmost importance now, for it serves as a prelude to the high degree of blending required in the final step.

First, I lay in my final background of raw umber, sharpening the outlines of the rim and sides of the bowl. Now I use strokes and spots of white to accentuate the highlights and reflections seen on the rim and extending from the rear edge of the rim. Due to its curvature, the bottom of the bowl houses a complex pattern of reflections and I use Tones 1, 2, and a combination of raw umber and ultramarine blue for the darkest spots. I finally dab in a few spots of pure white for the highlights.

The ultramarine blue and raw umber is also for the darkest reflections seen in the stem and base and I use pure white for the highlights. To complete this step I combine yellow ochre and raw umber to outline the perimeter of the base where a yellowish reflection appears. Then I paint the extremely faint shadow extending from the glass to the lower left with Tone 1 and brush it very lightly into the white.

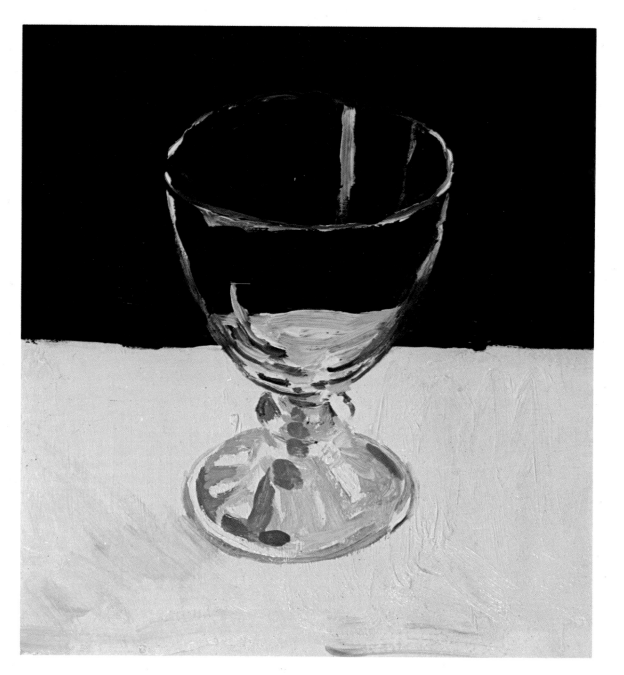

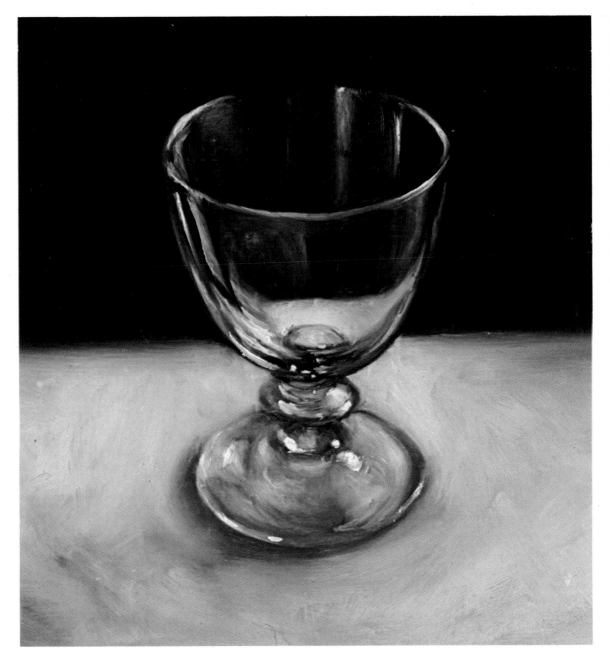

Glass: Step 4. I add cobalt yellow (aureolin) to my palette to mix with yellow ochre for the yellow reflections. Except for the final bright highlights, the entire process of creating a glassy effect consists of blending what you've already laid in. I begin by blending together the tones in the bottom of the bowl stem, and base of the glass just well enough so they merge softly.

To show the translucency of the glass against the background in the upper portion of the bowl, I use a sable brush to lightly blend the white rim and highlights into the raw umber already on the inside of the bowl. Notice that slightly more white is apparent in the front section of the bowl than in the rear due to the double thickness of glass that you're looking through. Now I'm ready to add my bright touches of highlights and reflections. These take the form of streaks or dots — such as the yellow streak on the left side of the bowl or the dots of color in the bottom of the bowl.

After changing the paper beneath the glass to a bluish gray, I mix raw umber and ultramarine blue together to use for the shadow around the bottom rim on the right and the cast shadow extending from the left side of the rim.

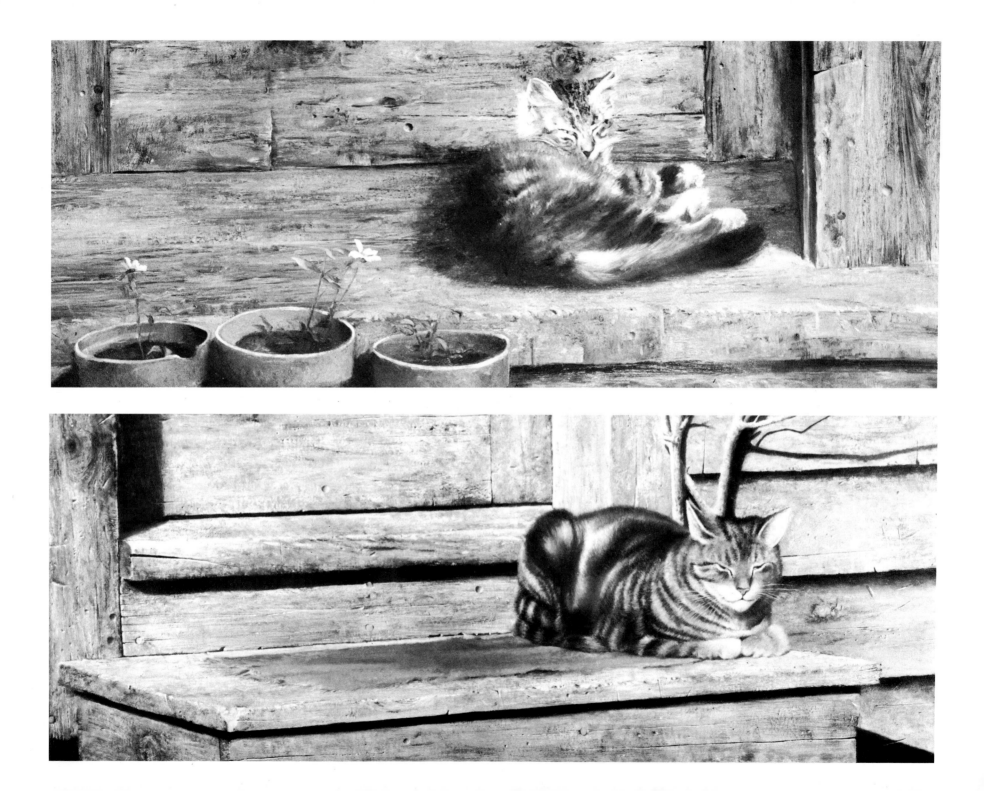

DEMONSTRATION 2
FUR

Fur is a very pleasant subject to paint. It's not only beautiful, but simple to render. I don't mean to give you the impression that painting fur is a snap, but in relation to other problems in this book it's one of the least complex.

When painting fur you can be free with everything except texture. Accurate drawing isn't a prime concern because fur has no strict outlines. The colors can be a wide range of browns, grays, or even white, and the highlights are simply lighter areas within the fur color. One area to be aware of is your light source. You must maintain shape and form, and you do so with highlighted and shadowed areas. The light in this demonstration is from right to left and its shading effect helps to create the distinct form of the hat and jacket.

Another problem is the *manner* in which you treat these lights and darks. They must blend together without harshness, but not so smoothly that the fur effect is lost. The tones between the lights and darks must be accurately graded, yet brushy enough to retain the quality of fur.

All that's needed to overcome the problems of painting fur is some practice. Because of the natural beauty of fur, this practice should be just plain fun!

Fur: Step 1. I use underpainting white instead of titanium white on my palette throughout this demonstration. I begin by outlining the body, head, and hat with Tone 1. I want to have the proportions correct before painting in the jacket.

Next, I take Tone 1 and apply it in short strokes all through the jacket area. I paint in this manner to avoid any harshness and to enhance the furlike image I'm seeking.

Tone 0 is brushed over Tone 1 in the same short-stroked brushy manner — more heavily on the right side, where the light is strongest, and less heavily on the left side, which is shadowed. Notice that Tone 1 is left exposed in horizontal streaks to show where the pelts are joined together.

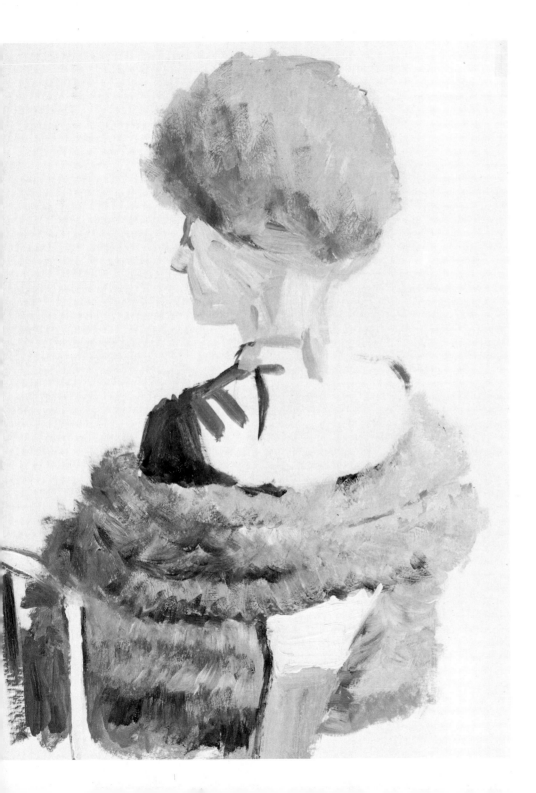

Fur: Step 2. In this step I want to properly locate various tonal values while constantly maintaining a furry texture.

The interior of the hat is filled in with Tone 1. I lightly stroke in Tone 2, working from left to right, to portray the shadow and provide form.

I use all my Tones for the jacket, working mainly with Tones 3 and 4 on the left and Tones 1 and 2 on the right. Notice the gradual change of value that takes place as the left blends into the right. This must be subtle, allowing no apparent definitions. One helpful way to do this is to build up the paint with a bristle brush and then to brush and splash the paint outward with a sable brush.

Notice that my strokes follow the direction of the fur instead of being random. I want to create an effect of fur — not wild fuzz.

Fur: Step 3. I'm adding ultramarine blue, Venetian red, and yellow ochre to my palette. The background color is a combination of ultramarine blue, white, and raw umber.

My objective is to lay in the various browns and blacks seen in the fur. All colors are applied in the same splashy manner seen in the previous steps, brushing back and forth into the background and into the dress to maintain the furlike look.

I mix ultramarine blue and raw umber for the black color used primarily on the left side, but also on the lower right side. To capture the dark browns I use raw umber. The lighter browns are ultramarine blue, Venetian red, and yellow ochre mixed together in varying strengths. I find the light tones applied over the dark tones create even more color variety. White and yellow ochre are combined for the highlight areas, such as those in the upper right portion of the jacket.

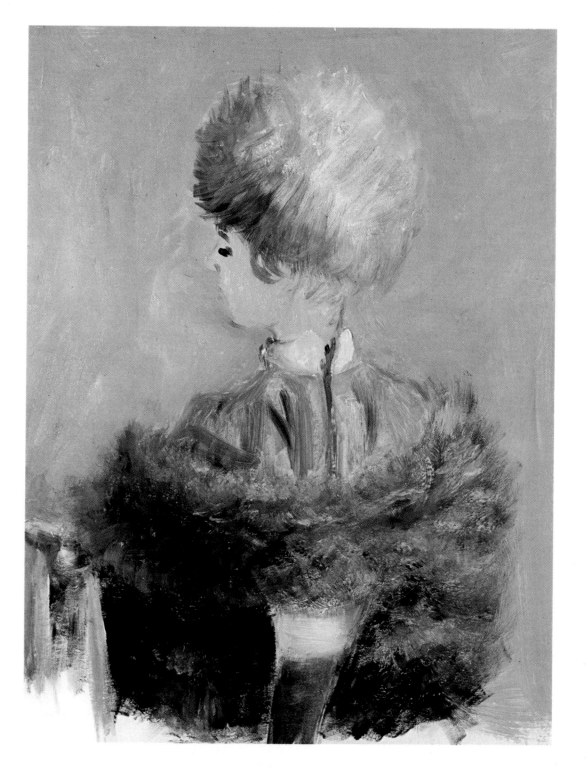

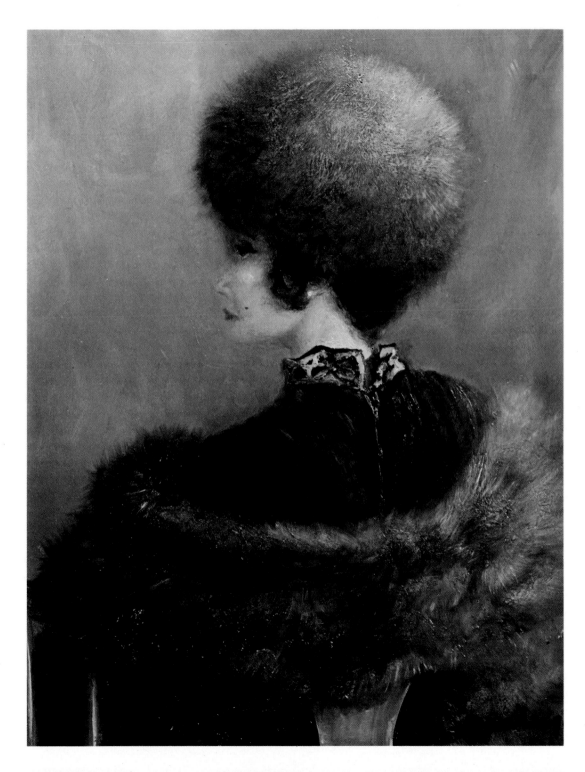

Fur: Step 4. This step is strictly a glazing and tinting process, so the painting must be thoroughly dry before proceeding. I add burnt sienna, Mars yellow, ivory black, and cobalt yellow to my palette. The background is a combination of ivory black and white.

The entire canvas is covered with painting medium and I consistently dip my brush into painting medium before using each color.

Raw umber is lightly glazed over the entire fur area but I remove this glaze with a dry brush where I want the lighter areas of fur to be exposed. The more glaze I remove, the lighter the fur will be. Where the fur needs to remain dark — such as on the shadowed left side and where the pelts are joined together — I leave the raw umber. Using a soft brush, I accentuate the highlight areas with a combination of burnt sienna, cobalt yellow, and white.

All the edges must be feathered to maintain the furry look. In the dark shadowy portions I feather raw umber outward with a soft sable brush. A combination of Mars yellow, ivory black, and burnt sienna is used in the same way to feather the lighter areas and also to blend any dark and light areas in the fur if they seem too harsh.

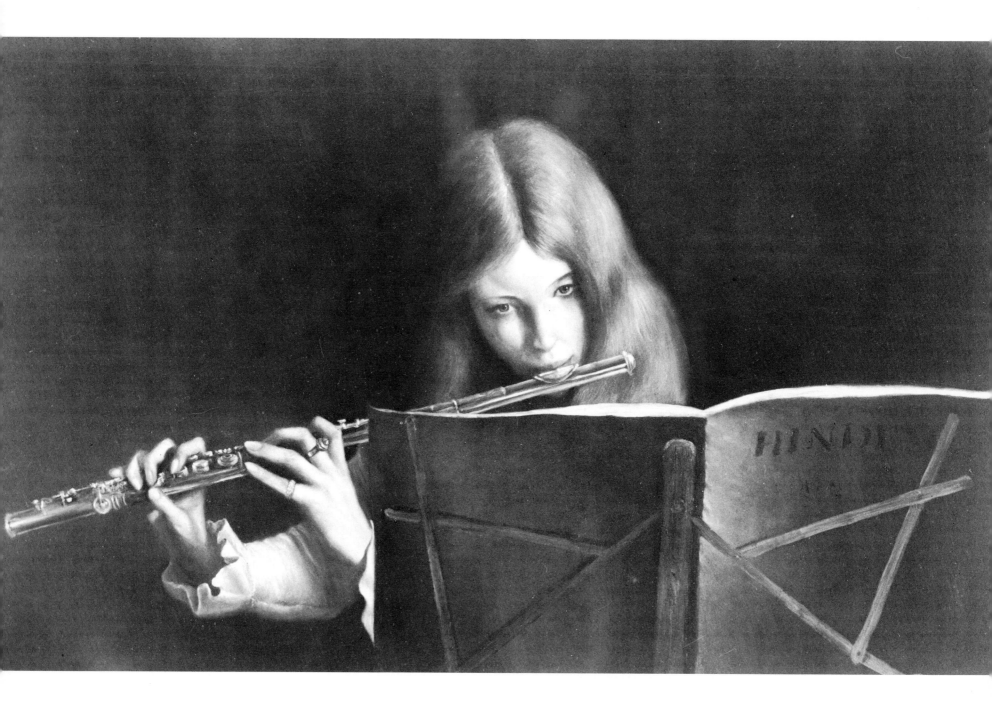

DEMONSTRATION 3
SILVER

You can visualize the general appearance of silver and can contrive an accurate mental image of its beautiful texture. But actually, after examining what is *really* there, you wonder how you can begin to paint it. What you see is a series of reflections on a shiny silver background that are distorted into unusual shapes bearing little resemblance to the objects reflected. No two pieces of silver, therefore, will ever appear to be exactly alike; each will be drastically affected by its surroundings.

The problem in painting silver is to capture these reflections. But remember that enough silver tones must be interspersed with the colors of the reflections to show that they emanate from a silver surface.

There are two approaches to painting a silver surface. One is to copy the silver exactly, being as precise as possible in painting the reflections and etched patterns. The other is to use the piece in front of you only as a guide, allowing yourself some freedom in rendering the subject. I've used the latter approach for this demonstration. Don't take liberties with the rendering of the shape or proportions of your subject as a whole or you'll destroy the base which controls the reflected patterns. Any departures from a realistic rendering you do make within the permitted range should be minimal for one simple reason: silver is too difficult a subject to play around with!

Etched patterns and filigrees offer a main source of interesting colors and highlights, but don't vary from reality unless you're positive that you're within the realm of possibility. I've found it helpful to exaggerate the tonal values of silver by making the darks slightly darker and the lights slightly lighter.

Although silver is difficult to paint well, it need not be frightening. If you approach your subject slowly and carefully, as I'll describe in the following steps, I don't think you'll find any major difficulties.

Silver: Step 1. For this demonstration, I'm adding a small amount of phthalo blue to Tones 1, 2, and 3 on my palette while leaving Tones 0 and 4 as they are. I now have three silver-blue tones of varying strengths to capture the silver tones of the urn.

I thin Tone 2 with turpentine to loosely draw in the general shape of the urn. In some areas I even use angular lines — like those around the base of the urn — to help me gain the proper proportions. To further indicate perspective and proportion I take thinned Tone 3 and dab in a few major shadows, such as those on the handle and lid.

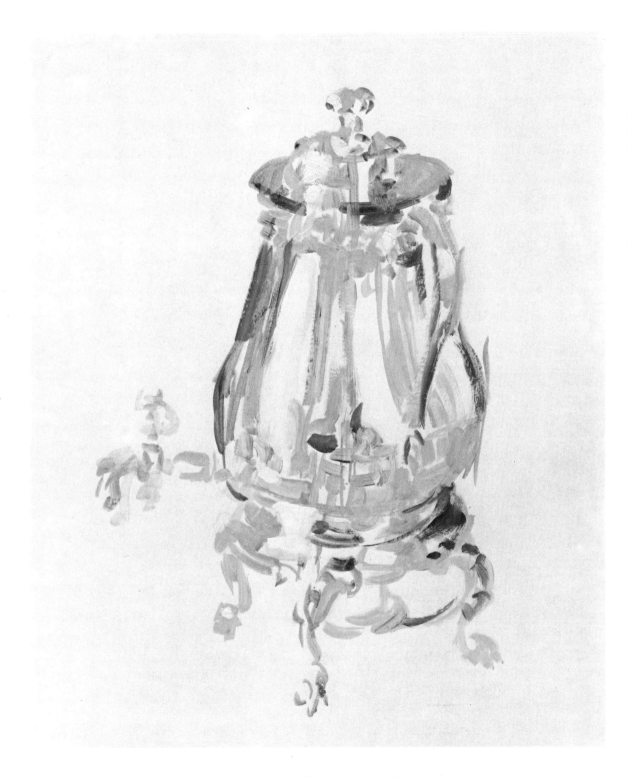

Silver: Step 2. For this step my palette remains unchanged. My objective is to paint the entire urn by roughly indicating all the values or reflections in vague, broad strokes. Capturing the value and location of a reflection accurately is far more important than painting its precise shape.

I use Tone 1 to fill in the lightest silver values found in the lid, the base of the pot, the handle, and the feet. I lay in the darker silver values found all over the urn with Tone 2. Tone 2 is also what I use to sketchily add the etched pattern found at both the top and bottom of the pot portion of the urn. I use Tone 3 to add major shadows — such as under the lid, along the left side, and under the pot on the right.

To capture the highlights on the handle, in the large streaks in the pot, and on the lid, I use Tone 0. As these tonal values are filled in, note that the basic drawing automatically becomes more refined.

Silver: Step 3. I expand my palette to include yellow ochre, underpainting white, burnt sienna, and more phthalo blue. In this step I concentrate on refinement and accuracy. Note that my brushstrokes follow and accentuate the shape of the urn.

I mix yellow ochre with blue and burnt sienna to get a dull greenish brown which I use thinned with turpentine to indicate the background. For the reflections of the background in the urn, I use the same color with white added for coolness. Examples of this are the long streak in the center of the pot, the curving streaks on the lid, and other areas previously indicated with Tone 2.

There are some warm reddish reflections, so I take yellow ochre, mix it with white, add more burnt sienna but less phthalo blue than described above and place it where needed, such as on the handle and on the streak on the far left side of the pot.

I mix more blue into the original Tone 1 used in Steps 1 and 2 for areas such as the right side of the pot, lid, and base. The darkest tone — like the shadows of the feet — is phthalo blue and burnt sienna mixed to a near black on the cool side. I use underpainting white for the pattern areas at the top and bottom of the pot. I'm toning down all the areas filled in with white in Step 2 by mixing small amounts of burnt sienna and blue into white, giving me a bluish-gray, off-white color.

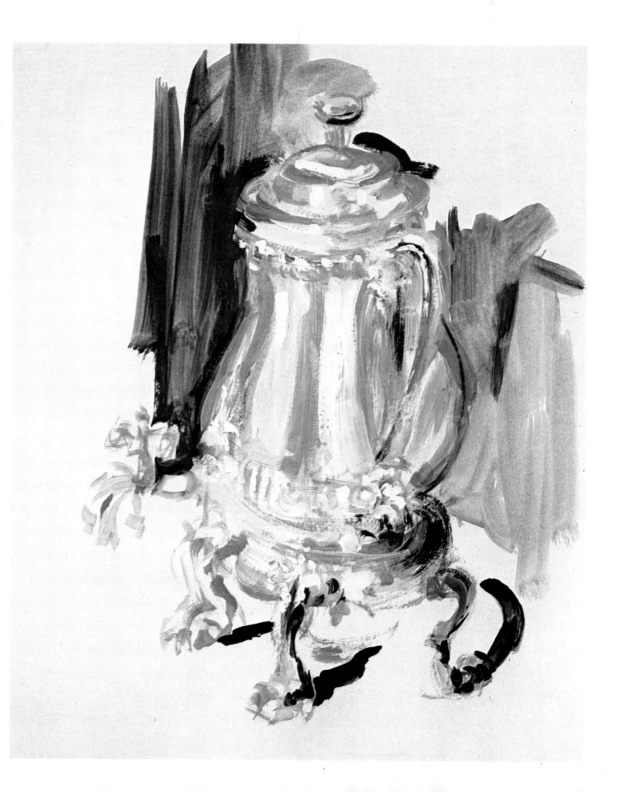

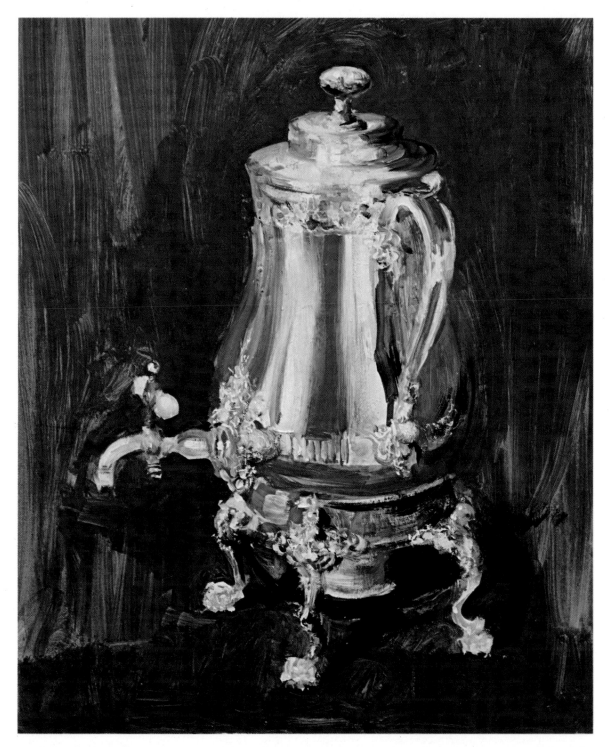

Silver: Step 4. Now it's important to lay in precise colors in their proper locations to refine the shape of the urn and enable me to blend accurately.

Blue is the predominant color reflection, so I use Tone 1 with extra blue added for the spots on the lid, handle, and left side of the pot. Note that I'm blending most of these blue reflections subtly. For the red reflections, such as the long streak by the handle, I'm using straight burnt sienna left unblended for intensity.

I use my phthalo blue and burnt sienna combination for the darkest portions of the urn, like those on the right side, on the lid, and for the shadows at the bottom.

I use underpainting white exclusively for the etched pattern areas. After sitting on my palette for half an hour or so, this white becomes extra sticky and is even more suitable. I apply it by twirling a #2 watercolor brush where I want to represent the pattern, producing a raised brushstroke. Titanium white is used for the bright highlights such as those on the handle.

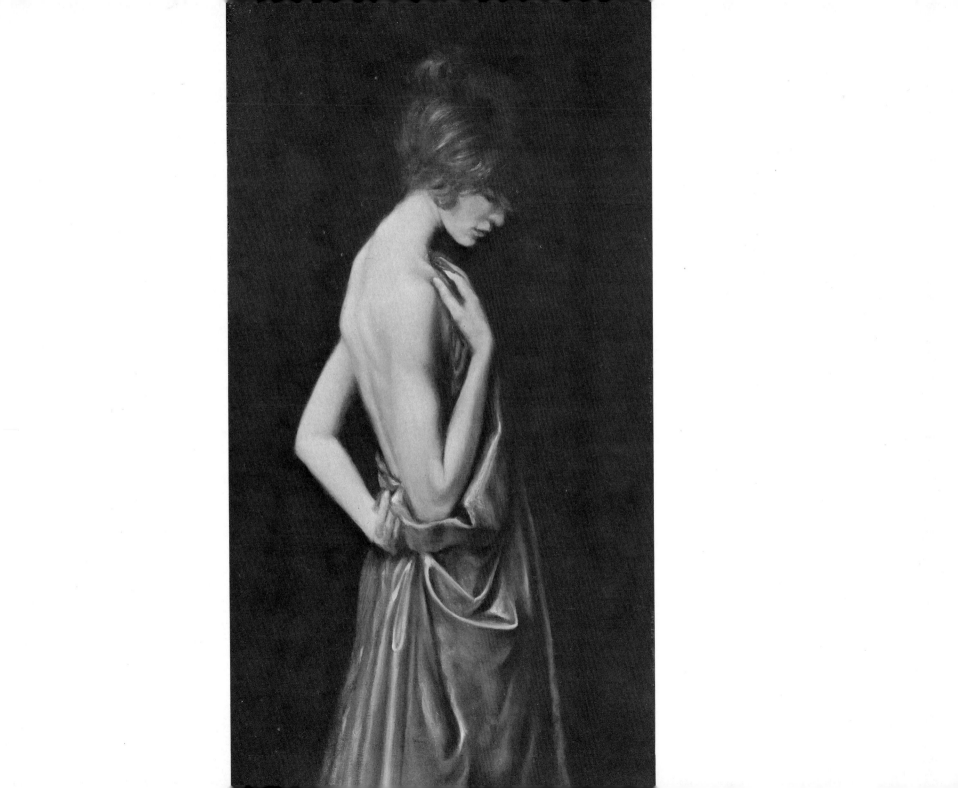

DEMONSTRATION 4
SHINY FABRICS

Draped Figure (finished painting, Demonstration 4), oil on canvas, 30" x 15". Notice that there's a softness to the drape even though it displays the crispness so characteristic of shiny fabrics. This crispness enhances the natural softness of the model. Collection of the artist.

Shiny fabrics have been a favorite subject of artists throughout the centuries. Some painters have portrayed this type of fabric so magnificently that people automatically associate their names with it, notably the Dutch masters, TerBorch and Vermeer. The expertise of such masters produces a startling beauty that cannot be overlooked.

A few of the fabrics that fall into this category are silk, taffeta, satin, and faille. These must be considered formal fabrics. As a matter of fact, I can't think of a single glossy fabric that would be suitable for a casual setting. To have something as stereotyped as this is wonderful; you know just what mood you'll evoke.

This group of fabrics has three main characteristics: they are closely woven, shiny, and medium to heavy in texture. The close weave naturally produces a shiny surface; it also produces the heavy texture which causes fabrics to fold and fall away from the model so characteristically.

Awareness of their physical qualities is very important in painting such fabrics. The consistently shiny surface reflects light from all sources, which produces a sheen unlike any other fabrics and causes them to almost glow.

The manner in which the folds fall is just as typical of this group. The folds are large and sweeping, the deep ones producing a high degree of contrast with the bright highlights of the rest of the fabric. They also angle sharply where a fold changes direction which provides contrast to the roundness of the straighter folds. In fact, I find placing these fabrics around my model very interesting because each move the model makes produces a new series of patterns. It may take a while to find just the arrangement of folds and contrasts you want, but keep trying. These fabrics lay beautifully, and you're sure to get the desired effect.

I've chosen to illustrate a length of taffeta draped around the back and side of a girl producing straight as well as broken folds. The details of the model are almost ignored, but I'll mention them so you'll be able to relate to the positioning of the fabric.

Shiny Fabrics: Step 1. For the first step, my palette contains the usual four tones, but they are made from Venetian red and yellow ochre rather than raw umber. Tone 0 is still white, but Tone 4 is a combination of a bit of Venetian red and lots of yellow ochre to produce a deep reddish rust color. Tones 1, 2, and 3 are gradations of color between Tones 0 and 4 mixed by adding more white to Tone 4 as I approach Tone 0.

The reason my colors are so toned down at this point is to allow me to increase the density of red needed and to brighten colors as I work; there's no "super-bright" available once you've reached the peak of your color!

I draw in the fabric outline, indicate the arms, and then completely fill in the fabric with Tone 1. With Tone 2, I indicate the largest and most prominent shadow areas.

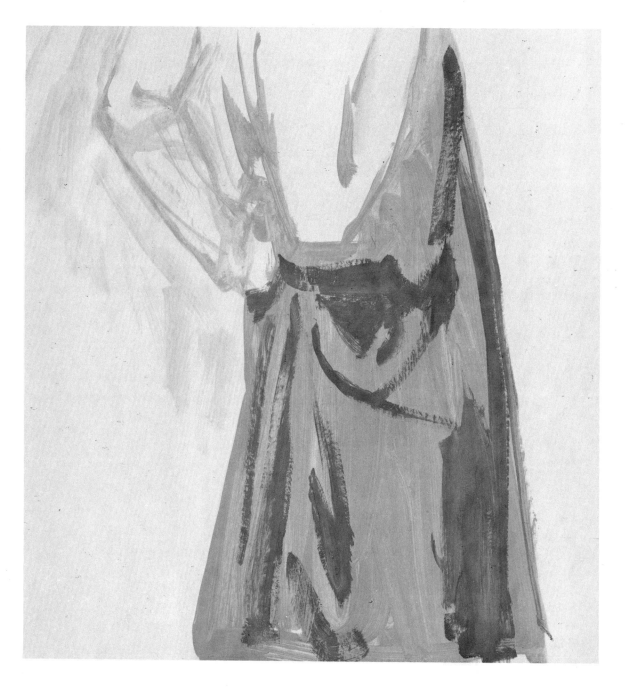

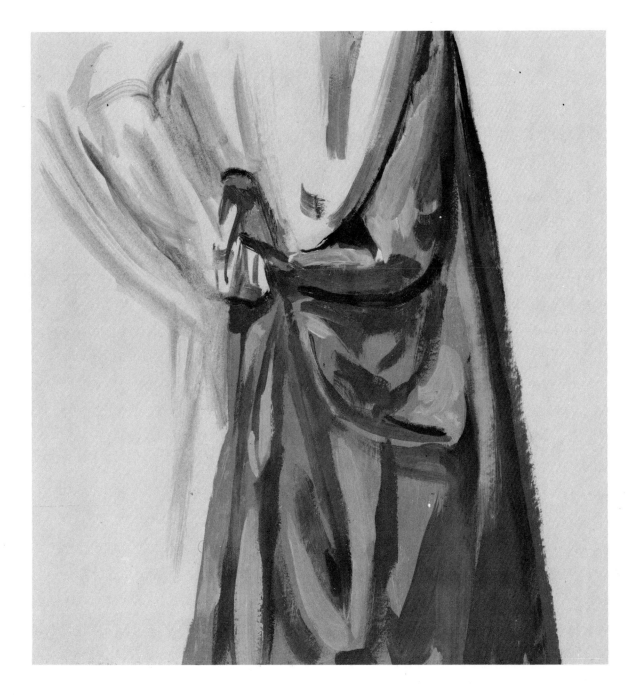

Shiny Fabrics: Step 2. In this step I'll complete the shadow areas, refining them to show depth and indicating the largest areas of highlights.

I continue to use Tone 2 for the additional shadows. Deep folds in the fabric create especially dark shadows and I use Tone 3 to define them. This depth can be seen in the vertical folds, such as those extending down the far left and those on the right side. I use Tone 4 for a few areas — such as the first sweeping fold below the right arm and the one straight down the far right side — that are even deeper. Tone 4 is also used under the hand and elbow to separate these from the fabric.

I select the main highlight areas — mostly along the top portions of folds catching the light — and lay these in with a combination of Tone 0 and Tone 1. An occasional bit of blending may take place, but I prefer to leave the tones generally unblended at this stage.

Shiny Fabrics: Step 3. Cadmium red light, cadmium red deep, and raw umber are added to my palette. I mix cadmium red light and deep together in equal amounts, then add a minute amount of yellow ochre to get the basic red color I want. I've decided to add another fold on the far left side for design and balance.

I continue to work with my basic red color, brushing it into all areas of the drape. I don't worry about painting over the highlight and shadow areas because the under-colors will automatically blend with the red as I brush into them, maintaining a workable impression of the position of the light and dark areas.

I use a combination of cadmium red deep and raw umber in the shadow areas. Raw umber is brushed into the drape where the shadows are especially dark, then this is blended into the red as seen on the large shadow in the lower right. In a few cases — such as under the right arm — the raw umber is left unblended.

The very lightest areas are white. The semi-light areas — such as in the center bottom — are a combination of white and cadmium red light.

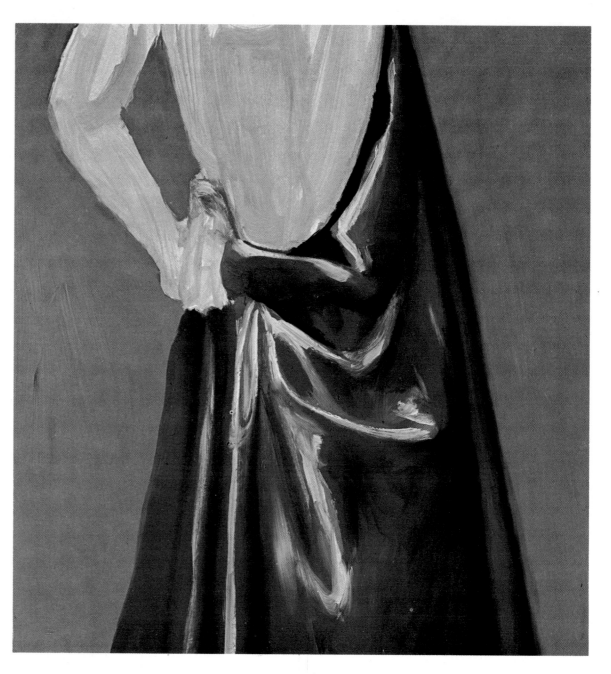

Shiny Fabrics: Step 4. At this final stage all the necessary groundwork should be done, so all that's necessary is to blend all the colors together and soften everything.

During the blending process, the raw umber will work to tone down and mute the red and gives me the opportunity to blend in cadmium red light and deep wherever I please for additional color. The brightest highlights require emphasizing with white after the drape is complete. For the skin tones of the arm and hand refer to the chapter on materials and methods, p. 20.

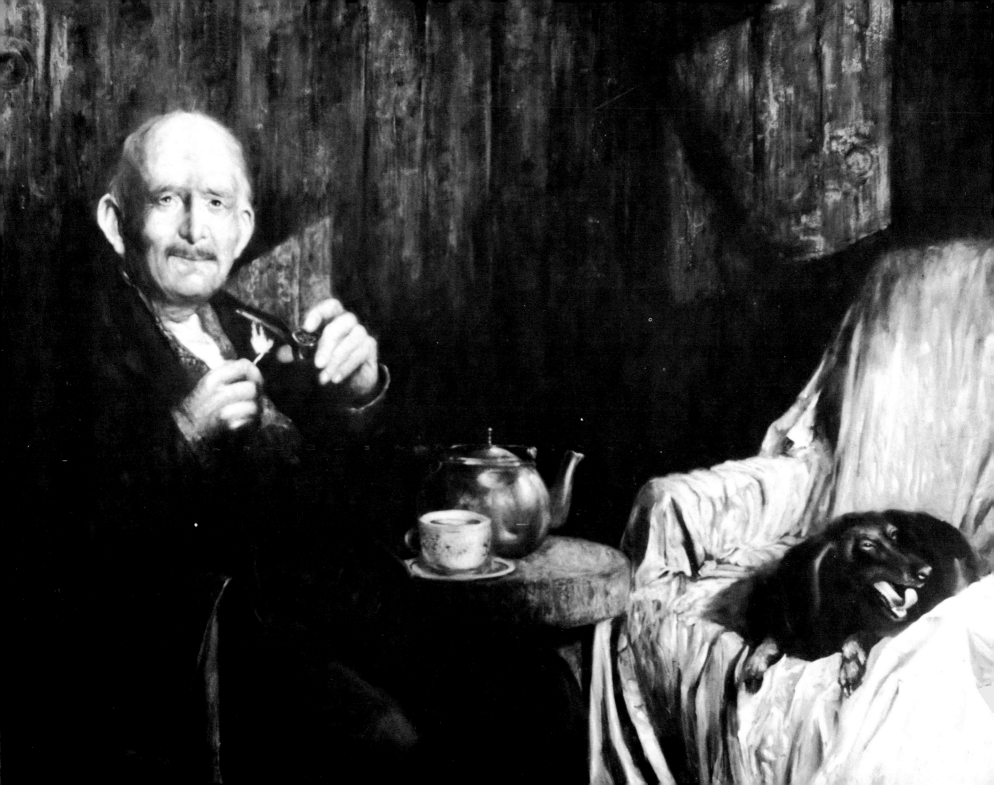

DEMONSTRATION 5
CANDLELIGHT

Old Man and Jules, oil on Masonite, 31-1/2" x 48". The main purpose of the flickering match is the same as the yawn of the dog — to capture a charming, fleeting moment in the day of a man. The match also adds warmth to the subject and the surroundings. Collection of the artist.

A lighted candle is an extremely deceptive object to paint. Although the flame of the candle forms the focus of the painting, there is almost as much impact in the effect this flame has on its immediate surroundings. To illustrate this, if you cover the flame in Step 4 of this demonstration, you'll still see the glow within and surrounding the candle and the warm highlights on the candleholder. The glow radiating from the flame itself should be the brightest area of the picture. The brilliance the flame casts on surrounding objects should be captured to heighten the brilliance of the flame, but nothing should outshine it.

The flame itself contains some interesting characteristics. The flame extends from the base of the wick, where it's a bluish, rather transparent color. As it rises, the flame forms a darkish, semi-transparent, yellowish arc. Then, at the top, the flame bursts forth in a glowing opaque yellow.

Notice also that no matter how still the surrounding air is, a flame flickers ever so slightly. This flicker can be rendered by carefully blending the flame along the sides and top in a slightly uneven manner, keeping the flame from appearing solid and rigid. Also, the surrounding "ghost," or glow, should be blended well into the background color to make it appear vague, but also contain varying streaks of visible color to produce a flickering effect.

Flame presents one major hardship to the artist, which you'll see when you tackle this subject: when your eye moves from the canvas to the candle, the brilliance of the flame will tend to distort your vision so that when you return your glance to the canvas your sense of color will be temporarily disturbed. There's no remedy for this; awareness of the problem is your only defense.

Candlelight: Step 1. I've changed the tones on my palette in this demonstration. Tone 0 is white and Tone 4 is a combination of raw umber and yellow ochre. Tones 1, 2, and 3 are mixed by adding varying amounts of white to Tone 4, producing the desired range of tonal values.

The outline of the flame and the dot representing the wick are Tone 2. I also use Tone 2 for the large, dark part of the candle in the center and on the right. The lighter portions appearing on the left and top right are Tone 1. I've outlined the rim of the holder with Tone 2 and also streaked Tone 2 in lightly to indicate the stem and base of the holder. Tone 1 is used for the shelf of the rim on either side of the candle.

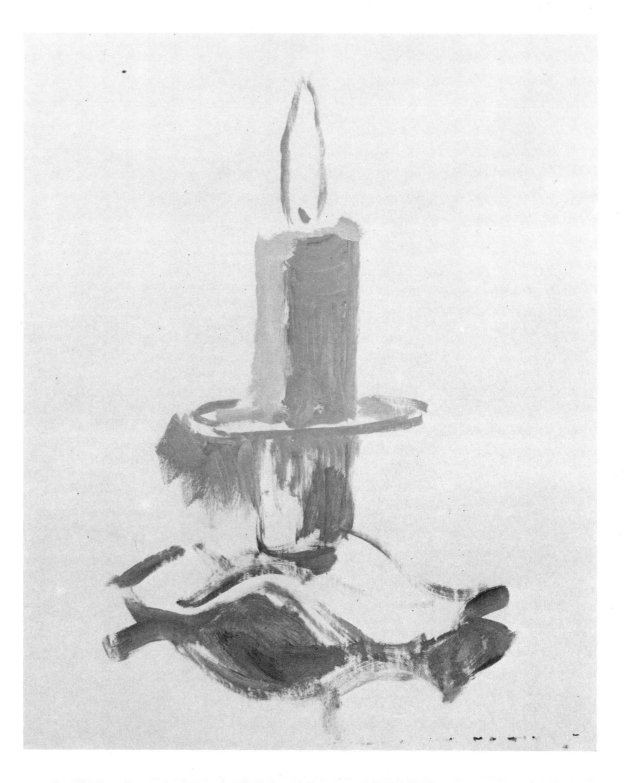

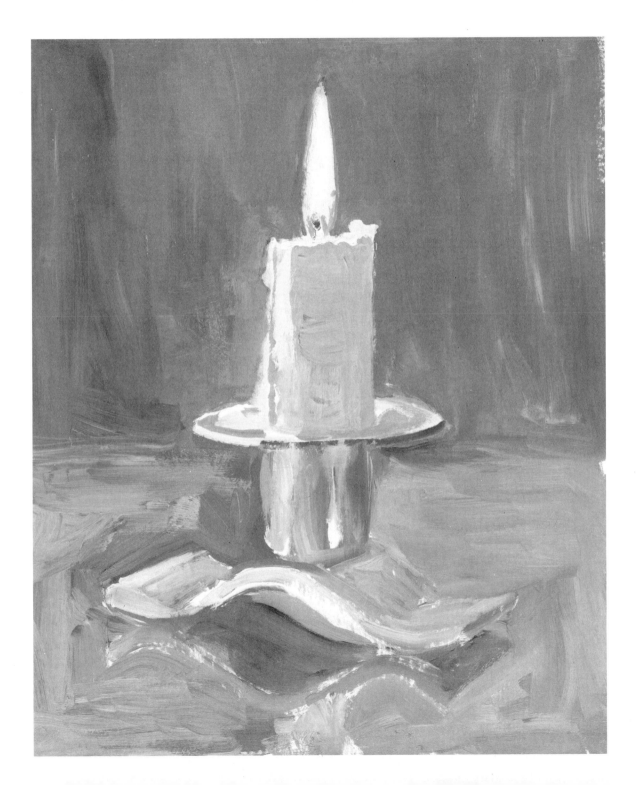

Candlelight: Step 2. I've filled in the background with a combination of Tones 2 and 3. The flame is Tone 0 and the burned top of the wick is a dot of Tone 3. On either side of this dot I've placed a stroke of Tone 2 which provides the impression of translucency surrounding the wick.

I brushed Tone 0 on top of the Tone 1 areas in Step 1 — such as on the left side of the candle — which results in a nice off-white color. For the darker right hand side of the candle, I brush Tone 1 into the Tone 2 already there. The highlights on the rim are Tone 0, with Tone 3 used for emphasis along the center and right edge of the rim. The candleholder, like the candle, has Tone 1 brushed over the Tone 2, with Tone 0 used for the areas of reflection.

Candlelight: Step 3. My objective is to lay in the colors needed for the final blending and refining in the last step. I add cadmium yellow, burnt sienna, raw sienna, yellow ochre, and phthalo blue to my palette.

The tabletop is a mixture of burnt sienna, yellow ochre, and phthalo blue. The background is raw umber.

I lightly brush white into the shimmer area around the flame, allowing the raw umber to remain dark all along the edge. This dark edge is characteristic of a flame and helps to emphasize its brightness. I lightly brush raw umber into the bottom of the flame around the wick and use raw umber and raw sienna for the center area above the wick. Then I brush a mixture of cadmium yellow and white into the brilliant upper portion and lightly into the white shimmer area.

The candle is filled in with cadmium yellow and raw sienna. I use a mixture of yellow ochre and raw umber for the darker parts of the candle. White is used for the melted wax at the top of the candle and along the left side. I fill in the candleholder with cadmium yellow and raw sienna, shadow with yellow ochre and raw umber combined, and use burnt umber for the very darkest parts of the holder. I use white for the lightest highlights — such as on the front edge of the base.

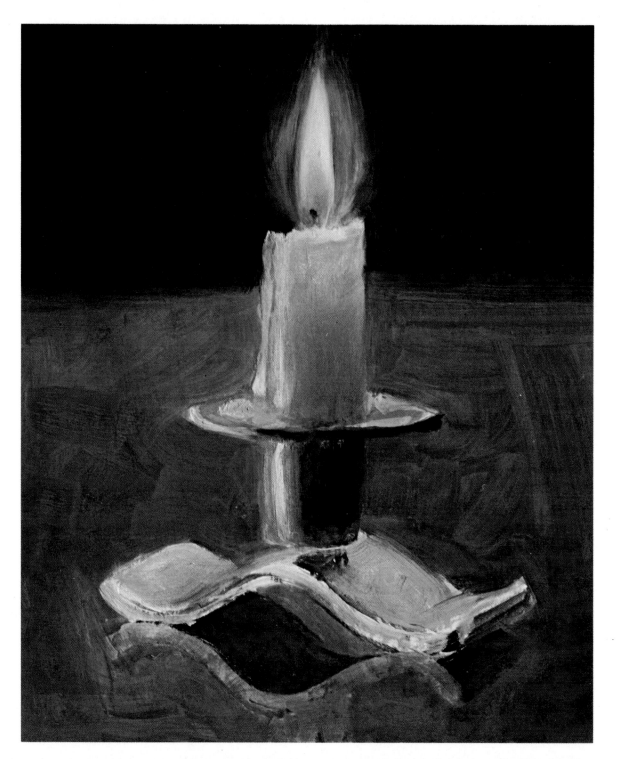

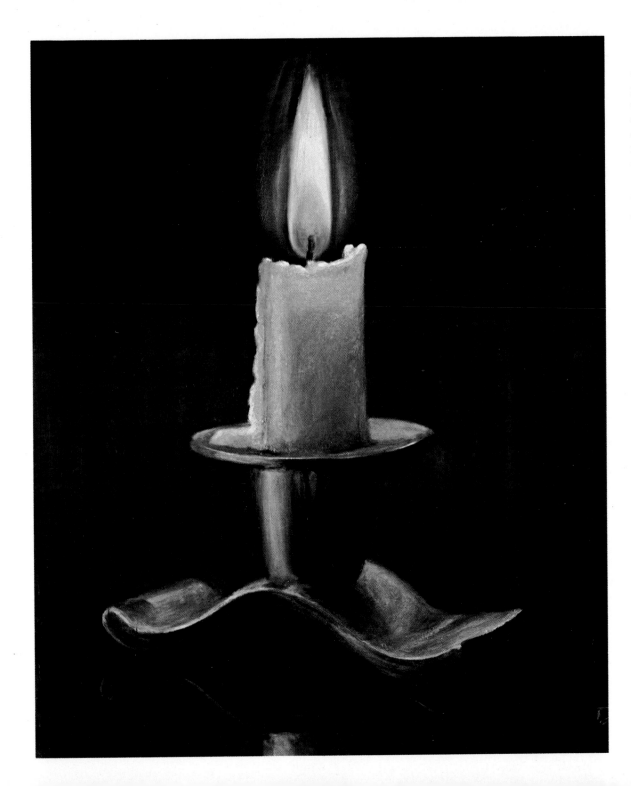

Candlelight: Step 4. The flame is now basically complete except for the slight amount of ultramarine blue and white blended into the bottom of it. The wick is defined with black. I blend the shimmering "ghost" carefully into the background, but allow streaks to remain less blended to enhance the flickering effect. The edges of the flame are also lightly blended into the background.

To render the transparent glow of the upper part of the candle, I make the lower part more opaque by brushing a little more raw umber and white into the base. Raw umber is also laid in under the ridge of drippings at the top to show the pale shadow.

I finish the candleholder by blending and refining the work done in Step 3 and adding white highlights where needed, such as on the edge of the rim.

DEMONSTRATION 6

ROUGH-TEXTURED FABRICS

Girl with Towel (finished painting, Demonstration 6), oil on canvas, 30" x 15". The two towels are almost solely responsible for conveying the mood and story of this painting. They provide a soft flow of lines that contribute to the overall design and make it obvious that the girl has been bathing. Collection of the artist.

"Rough-textured" is a very general term, so I've limited my demonstration to terrycloth. As with other fabrics, my main concern is capturing its texture and movement.

Terrycloth is a soft, medium-weight fabric which, when rumpled, produces many folds. Its suppleness eliminates the angular folds found in shinier, stiffer fabrics, instead producing flowing, parallel lines.

Since terrycloth is fluffy and thick, each fold tends to be fairly deep and wide and is softly rounded at its peak. To capture the deep folds on canvas, I use very dark tones in the pit of the shadows and a middle tone to blend the area between the extremes of shadow and highlight. I find just blending, without this middle tone, is not enough to maintain the soft appearance of the folds.

The texture of terrycloth is unique, but it poses the same problems in creating a rough, nubby effect that other textured fabrics do. I personally find using a rough, splashy technique more desirable than trying to work in a more defined manner.

All in all, rough textures are among the easier fabrics to render and produce very satisfying results upon completion. The roughness of terrycloth next to delicate skin tones can provide a striking contrast, and the folds can be shaped into lovely, soft patterns around the figure.

Rough-Textured Fabrics: Step 1. I use underpainting white as my white for my tonal values and throughout this demonstration. I begin by painting the outline of the model's head and body with Tone 1. I'm trying to capture the correct tilt of her head and the angle of her body so the placement of the towel will be accurate.

I continue working with Tone 1 as I roughly brush in the angular outline and major folds of the towel. Tone 3 is used for the hair which shows around the face and for the shadow produced by the towel on the jaw and neck.

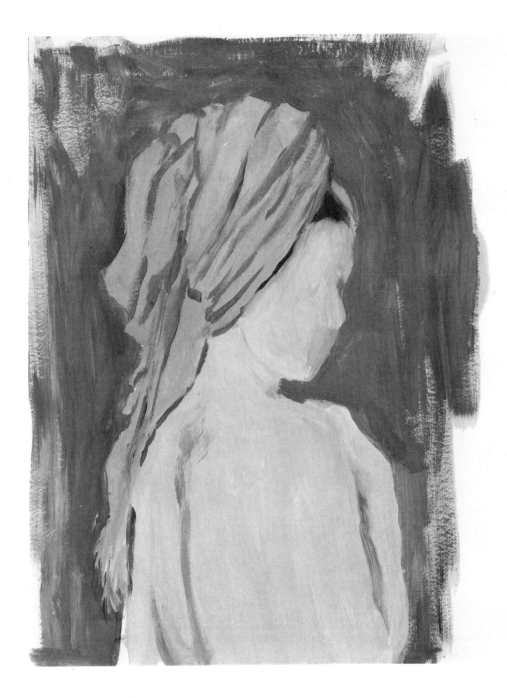

Rough-Textured Fabrics: Step 2. After I'm satisfied that the towel is in proper relationship to the model, I fill in the entire towel area with Tone 1. It doesn't matter that the folds placed in Step 1 are erased, since they were laid in only to provide a basic impression.

With Tone 2 I add the shadow areas of the folds. The deepest folds are painted with unblended brushstrokes; the shallow folds — such as in the upper far right — are blended slightly. For the shadow areas between the body and the towel I use Tone 2.

I use a combination of Tones 0 and 1 to fill in the body and face, indicating the major dark areas — such as the backbone — with Tone 1. The features are indicated by the addition of more Tone 1 to the combination of Tones 0 and 1. Next, I paint in a rough background of Tone 2 around the figure.

Rough-Textured Fabrics: Step 3. I now add raw sienna, yellow ochre, cadmium yellow light and Venetian red to my palette for the basic skin tone. The darker skin tone used for features and definition is a combination of Venetian red and Tone 2. I fill in the towel with a mixture of yellow ochre, underpainting white, and cadmium yellow light, trying to keep the fold lines in their proper places. Then I emphasize each fold line with two colors: raw umber for the deepest portions of the folds and raw sienna for the lighter shadows. Since these two colors represent the gradations in each fold, I lightly blend them into the yellow toweling.

To produce the texture of the towel I dab and scumble, allowing the paint to become thick and tacky. Where the towel hangs down the back and fringe is exposed, I feather the yellow ochre into the background. I'm careful *not* to work back and forth as I do this, since this would obliterate rather than accentuate the fringe.

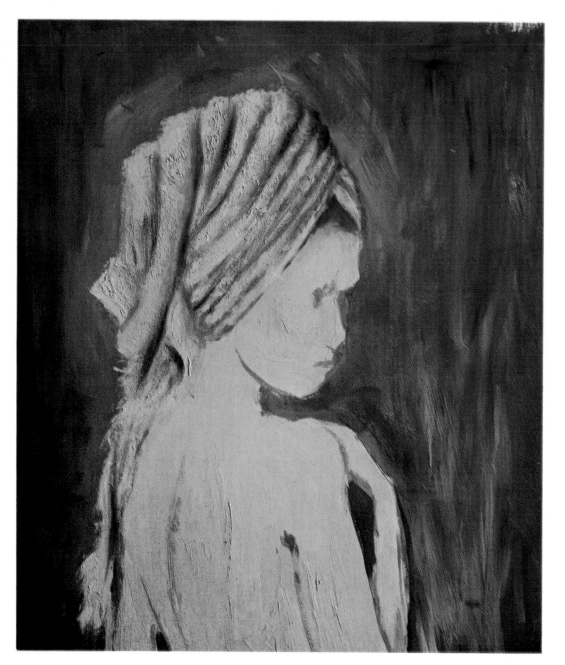

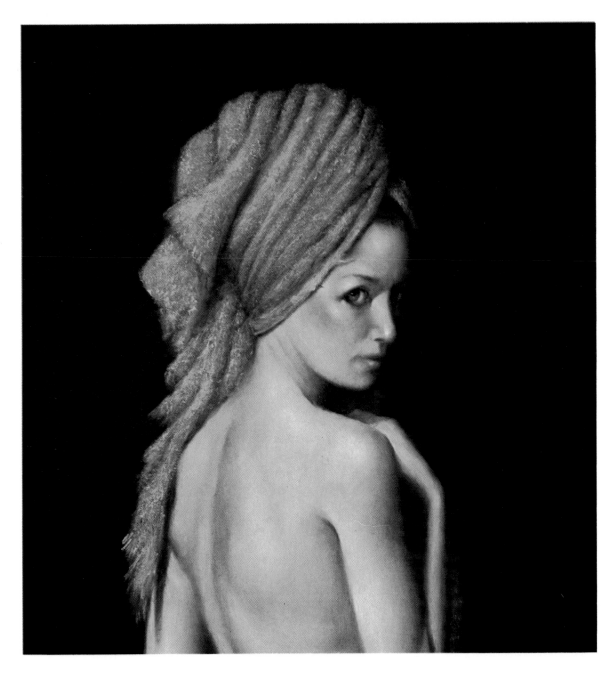

Rough-Textured Fabrics: Step 4. I don't begin the finishing touches until the entire painting is dry to the touch. I now add cobalt yellow to my palette and mix it to a workable consistency with painting medium. I allow this to sit for about an hour, until it has a pliable consistency.

Then I cover the entire painting with basic painting medium. I paint the entire background with raw umber and lightly glaze this over the towel. With a dry brush, I lightly wipe this glaze from the elevated portions of the folds.

Now I take the cobalt yellow mixture and dab and brush it into the towel, blending into the folds as I work. I continue dabbing the cobalt yellow on thickly until the desired degree of roughness is achieved. The skin tones are described in the chapter on materials and methods, p. 20.

DEMONSTRATION 7
FILMY AND LACY FABRICS

Cathy, oil on Masonite, 25″ x 21″
The lace in this costume not only
pleases the eye, but serves to enhance
the otherwise understated costume.
Collection Shirlee Rauchbach.

Filmy and lacy fabrics are deceptively simple in appearance. To render them well, however, more technical knowledge is required than for most of the other subjects demonstrated in this book. This is because these fabrics are always transparent — what is underneath or behind them is always visible — and the only way to handle this is to follow a procedure called *overpainting*. When overpainting is involved you should know the oil index numbers of all your paints or else you face the eventual problem of cracking paint. The rule is to overpaint with colors containing a higher oil index number than those used for underpainting. This process is referred to as "fat over lean," and is imperative to assure permanence. This procedure becomes very involved in this demonstration, since the overpainting covers virtually everything — skin, hair, dress, and background. You can see that it pays to plan ahead rather than discover suddenly that the oil index of the dress color is higher than that of the veil.

The next stumbling block in rendering these fabrics is the difficulty of correcting errors. If you make an error and try to fix it, you get a rubbed-out appearance instead of the translucent quality you're after. Therefore, you must be deft in handling both brush and color and be prepared to complete the overpainting of the fabric in one session.

With other fabrics the manner of folding is important, but with filmy, transparent fabrics what you're really seeing is multiple thicknesses of fabric instead of fold shadows. These thicknesses appear as concentrations of the fabric's color.

There are two approaches to lacy fabrics. One is to try to paint in every detail, the other is to capture an illusion of lace by using a dabbing technique. I prefer the latter and feel it's the more painterly approach, but the choice is up to you.

These fabrics add a delicate beauty when used in a painting, and can be rendered with nice results when you take a few minutes before painting to plan your approach.

Filmy and Lacy Fabrics: Step 1. I've mixed different tonal values for this demonstration, and I'm also using flake white for all my Tones. I'll be overpainting with white in the final stage, and this mixture of colors provides an excellent base. Tone 4 is yellow ochre mixed with a minute amount of phthalo blue and Venetian red, producing a brownish color. Tones 1, 2, and 3 are formed as usual by mixing 0 and 4 together in varying degrees of strength.

It's important to accurately represent the portion of the painting to be covered by the veil. I therefore begin work by using Tone 1 to draw in the girl, her hair, and her dress.

Work to capture the tilt of the head, the angle of the body, and the proper proportions. I completely ignore the veil at this point and concentrate only on the model.

Filmy and Lacy Fabrics: Step 2. I continue to expand the details of the model, lightly indicating the location of the veil.

The background and the hair are both Tone 1. For the hair I thin Tone 1 with turpentine. Thinned paint, plus the distinctive brushstrokes in the hair, provide the definition between these two areas. I paint the dress with a combination of Tones 0 and 1. The major folds are Tone 1 with the combination brushed into them.

Tone 0 is used to simulate the crown, as well as to rough in the outline and major folds of the veil itself.

Filmy and Lacy Fabrics: Step 3. I add Venetian red, yellow ochre, and titanium white, which I mix together for skin tone. I also add underpainting white. My first concern is to complete all but the finishing touches of the model. Once I start to paint the veil I don't want to have to rework the areas under it.

To paint the shadows and folds in the dress, I blend ultramarine blue and Tone 1 back and forth with the white. I apply underpainting white thickly for the crown, necklace, and lace on the neckline of the dress. I continue to use underpainting white for the veil, but apply it in very light, quick, long brushstrokes to encourage varying degrees of thick and thin. This also keeps me from picking up too many of the underlying colors. I let the paint remain very thin and sketchy as this helps produce the translucent quality I want.

Filmy and Lacy Fabrics: Step 4. I let the painting dry completely, then paint over the entire surface with painting medium.

To complete the dress, I add a combination of raw umber and ultramarine blue to the established shadow areas, brushing into the white as I do so. I then add highlights to the dress by brushing white into all areas except the shadows.

To complete the lace around the neckline, I first lightly brush the combination of raw umber and blue over the entire lace area. I then take a #2 watercolor brush and dab underpainting white in a random manner for the impression of lace. I lightly brush raw umber into the hair.

The background is a combination of raw umber and blue, only with more raw umber this time. I lightly brush this into the veil with a soft haired brush in places where the background is seen through it. I then brush titanium white lightly over the entire veil blending the background color and white together. I keep working back and forth with white and the background color until I reach the desired degree of filminess. The edges and bottom of the veil are softly blended with the background. Underpainting white and a #2 watercolor brush complete the points on the crown.

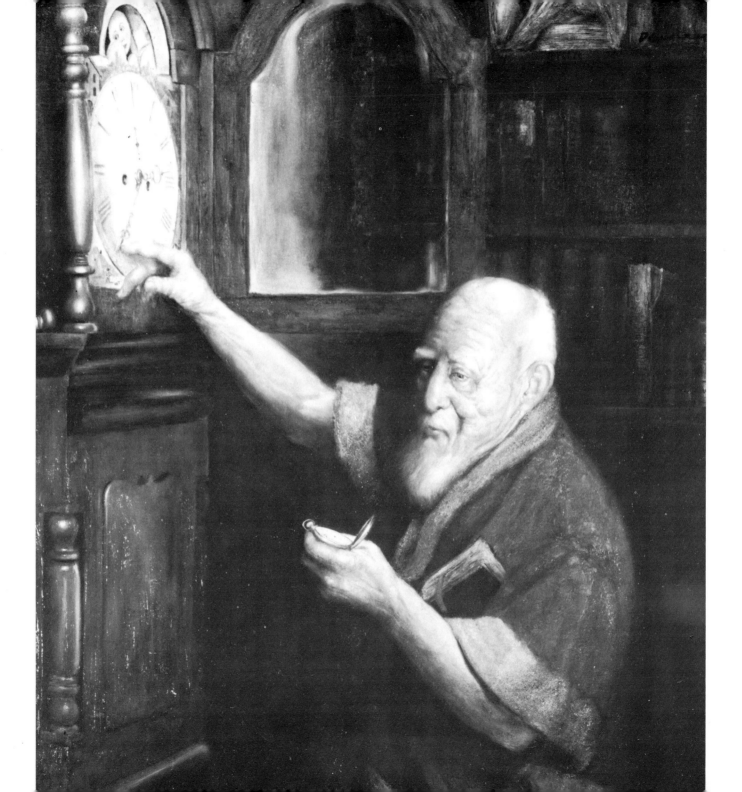

DEMONSTRATION 8
WOOD

To Bed with an Old Friend, oil on canvas, 60" x 30". Wood can often be used to clarify a figure in a painting. Here the wood draws attention to the clock, but doesn't detract from the main character. Private collection.

Creating interesting wood effects is always fun and rewarding. Well-rendered wood is a testimony not only to the artist's craftsmanship, but to his creative abilities as well. The object of this demonstration is not to be able to duplicate the graining and the patterns of the wood but to capture the feeling of texture and solidity. You can see that your imagination and "feel" for the subject are essential. *You* control the texture and the patterns of the wood by the way you employ the following basic technique. You will find this technique one in which an artist can integrate his own style and concepts of beautiful wood.

One of the problems you will face is knowing when to stop. You can keep "texturing" your wood and adding indentations, knotholes, and dents until you're past the point of good sense. One helpful guide is to keep your wood "in tune" with the rest of your painting. You don't want it to be out of step, either in mood or in technique. If your subject matter is such that you can't judge in this manner, just strive

for a beautiful and interesting piece of wood and avoid excess embellishments. Of course, if you have an interesting piece of wood in front of you, use that as a guide and control.

Remember that wood is not uniform in appearance and you can let the paint do what it may. For example, if you suddenly find you have created an unforeseen dark spot, instead of trying to even it out, see if you can use it to your advantage. Maybe a knothole would look terrific there. You'll find these controlled accidents can often work well if you don't become haphazard. Do emphasize the wood's unevenness and place your indentations artistically.

Creating beautiful wood is definitely a challenge, but I think you'll agree it's one of the most enjoyable projects you'll undertake.

Wood: Step 1. I substitute underpainting white for titanium white in all the tonal values. I need this thicker, quick-drying white to help me capture the effect of wood.

I use Tone 2 thinned with turpentine to draw the outline of the keg and the general location of the nails inside it. Still using Tone 2, I draw in the location of the two bands going around the keg at the center and at the bottom. I also lay in the perpendicular crevices where the pieces of wood come together.

The shadow on the right side of the keg and the cast shadow seen to the lower right is thinned Tone 2. Thicker Tone 2 is what I use for the deeper shadow inside the keg on the left. To define the upper rim above the right-hand shadow, I fill in the thick center portion of the rim with Tone 1.

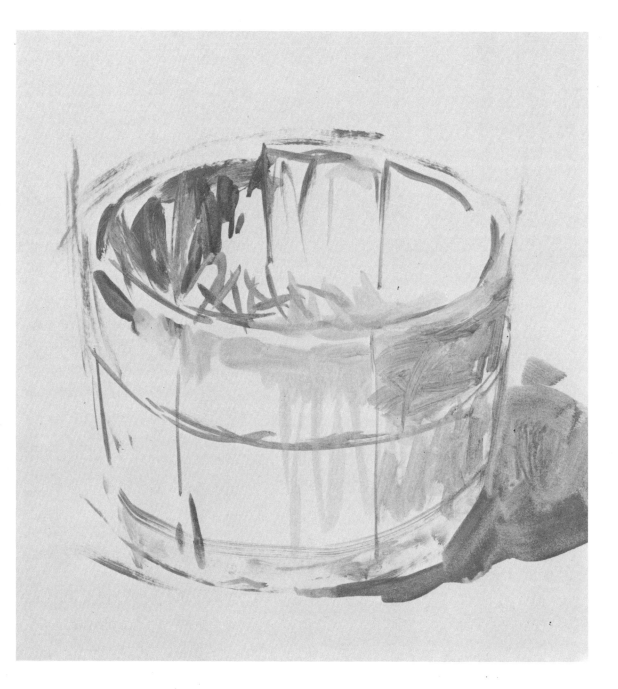

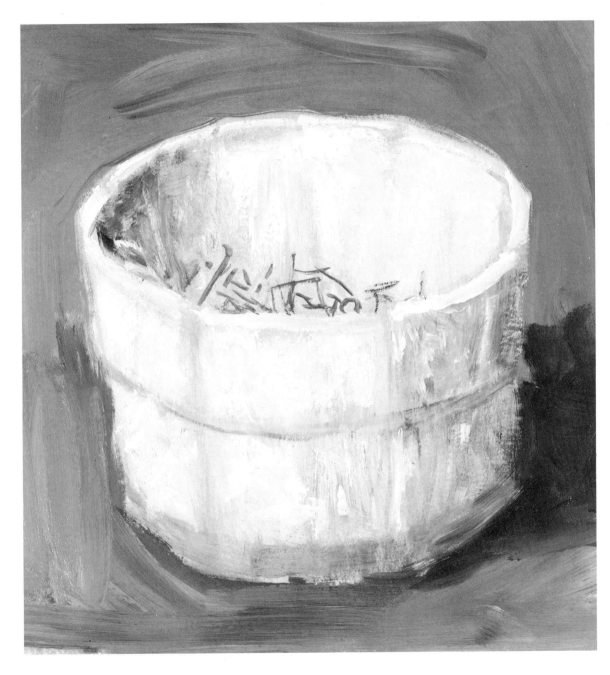

Wood: Step 2. My next step is to take underpainting white thinned with turpentine and brush this over the entire keg and nails, being careful not to destroy the drawing. Now I wait until this white is very sticky. I want the next layer of paint to pull and skip over the top of previously applied paint as I work.

I go over the entire wood surface using a 5/8'' brush with unthinned underpainting white and letting the paint skip and drag to create a rough, thick texture.

I use Tones 2 and 3 lightly to accentuate the bands and vertical joints. These areas are not rough in texture, so the paint should be applied smoothly. I use Tone 3 and raw umber for the variations in the right-hand shadow on the keg. Tone 3 is also used for the shadow on the inside left of the keg. Underpainting white is applied to the entire upper rim.

I now cover the entire background with Tone 2 and paint in the cast shadow on the lower right with Tone 3.

Wood: Step 3. I add burnt umber and ultramarine blue to my palette. Tone 3 is what I use to deepen the cracks and circular bands. Next I rub burnt umber into the bands to create a rusty effect. I'm trying to be moderately smooth since the bands are rough textured, but smoother than the wood, and I want this contrast noticed.

For the actual wood effect, I take Tone 2 and dab and drag it over the top of the white in a very rough manner. I'm very casual about my painting so the wood will be darker in some spots and lighter in others. This is just what I want. This same rough application is used for applying Tones 3 and 4 in the shadow areas on both the right side of the bucket and on the left inner portion of the bucket.

I add two dents for interest, one on the upper left and the other in the lower center. Notice that I take pains to portray the light source accurately by laying in my Tone 1 highlight at an angle directly opposite the shadow of the dent, which is Tone 3. Now that I have the wood effects in, I emphasize the cracks with Tone 4. Then I use a combination of white, raw umber, and ultramarine blue for the nails inside the bucket.

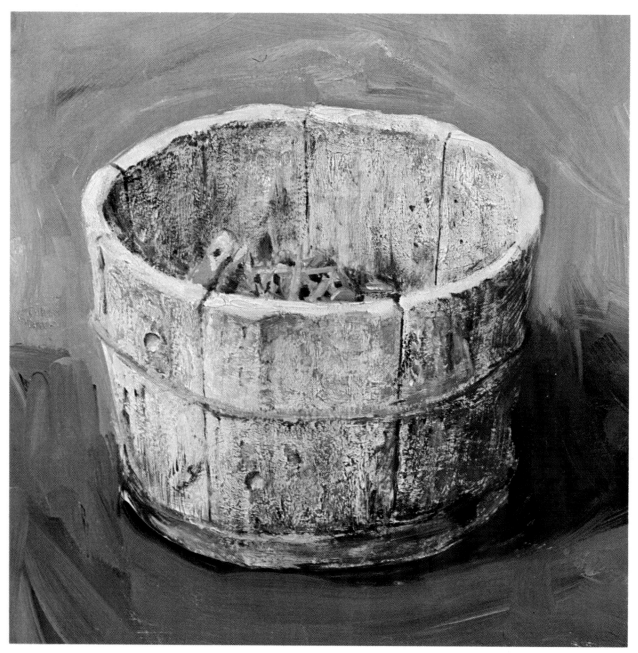

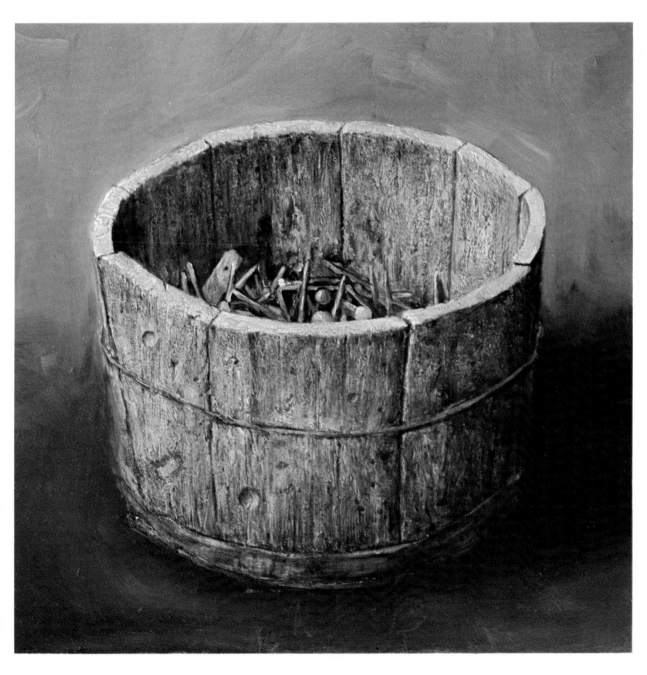

Wood: Step 4. I add burnt sienna, raw sienna, and yellow ochre to my palette. I combine burnt sienna, ultramarine blue, and raw sienna for a brownish tone and lightly paint this over all the wood areas using my basic painting medium and allowing the underpainting to show through.

Now I take raw sienna with a touch of blue and glaze this over the upper rim of the keg, just enough so that it doesn't look white. Before I add final touches to the wood, this area must be allowed to dry completely, so I'll finish everything else in the meantime.

To complete the bands, I glaze over what is there with a combination of burnt umber and blue, adding more burnt umber where the rust shows. I also add a little burnt sienna in the rust areas for emphasis. I complete the nails by refining the colors added in Step 3 and adding areas of highlight.

Ultramarine blue, raw umber, and a touch of yellow ochre and white mixed together is used for the background. I vary the shades of this so the top area is lighter than the bottom area. The shadow cast on the right is brushed in with raw umber.

After the wood area is dry (you may have to wait a day or two), I take raw umber thinned with my basic painting medium and glaze this over the wood again. This final touch brightens and highlights the wood.

DEMONSTRATION 9
FRUITS

Boy Eating Grapes, oil on canvas, 19" x 15-1/2". The grapes in this painting provide a vehicle: they allow me to paint hands engaged in an interesting activity as well as to portray the face in a different and engaging manner. Collection of the artist.

Fruits encompass a wide variety of shapes and textures. It's impossible to demonstrate every type of fruit, so I'll paint an orange for this demonstration. I feel an orange is more complex and interesting than a shiny fruit, such as an apple. An orange exhibits three textures found in all citrus fruits, so the techniques I mention should enable you to paint any other fruit in this category. The three textures we're dealing with in the orange are the outer peel, the white inner skin, and the pulp, and each has its own special characteristics.

The peel is bumpy and pitted, always shiny, and sometimes glistening from its own oil. The center of a highlighted area will be very bright, but as the light diffuses away from this center, the highlight will become speckled and splotchy due to the bumpy surface. The texture of peel and its effect on highlights dictates a special method of handling paint and I've chosen to employ a dabbing technique to create this texture.

The white skin is slightly rough, dry, and dull in luster. Therefore, the prime concern is not to capture its texture, but to keep it toned down colorwise in relation to the brighter highlights found elsewhere. The trick is to produce a dull white.

The pulp presents another problem. Pulp is composed of many little pieces that by nature are almost transparent, extremely moist, and smooth textured. Massed together, these form the sections of the orange. Each section, therefore, has a glossy, uneven surface ideally suited to reflecting any bits of light. As with the peel, I find a dabbing technique particularly suited for this glistening effect. The best-rendered orange in the world can't be displayed to good advantage if its surroundings do not provide an interesting contrast. I've placed my orange on a porcelain plate, which offers a wide spectrum of contrast and heightens this beautiful piece of fruit.

Fruits: Step 1. I use Tone 2 thinned with turpentine for the outline around the orange and for the faint outline of the separate peel to the right. I also indicate the outline of the pulp and the outer edges of the white inner skin with Tone 2. The entire pulp area is filled in lightly with thinned Tone 2.

Still using this tone, I lay in the perimeter of the plate in its proper relationship to the orange and fill in the interior of the plate with a combination of Tone 0 and 1. Next I show the location of the rim with Tone 1. Unthinned Tone 2 is what I use to paint the cast shadow to the left of the orange.

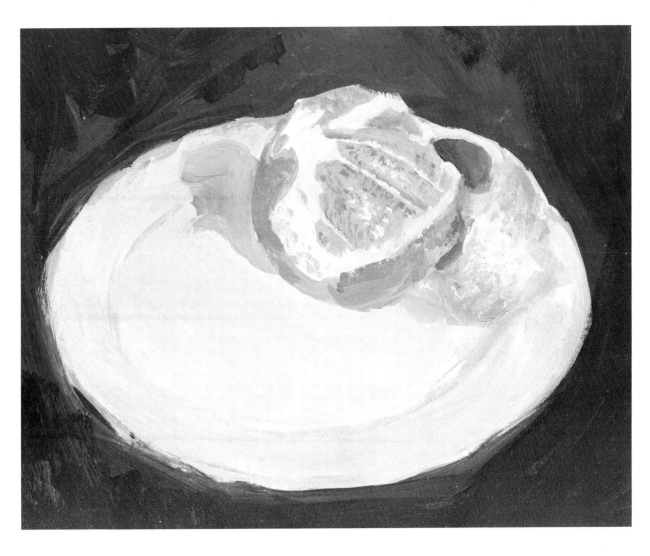

Fruits: Step 2. The first thing I do is fill in all areas with paint. I use Tone 2 for the peeling, Tone 1 for the pulp, and Tone 0 with a tiny bit of Tone 1 mixed in for the white skin. For the shadow inside the right peel I use Tone 3, shaded slightly with Tone 2. I don't apply any of this paint too thickly since I'll be working over it.

I begin to create texture in the orange peel area. With a 1/4'' brush, I take Tone 1 and paint in little separate dabs on top of the Tone 2 already there. This procedure can be seen easily on the separate peel to the right. On the right peel only, I dab in Tone 0 and Tone 1 to indicate the highlighted areas where the light hits it directly.

On the white skin areas, I add in a few dabs of Tone 1 where the skin might have bumps in it, such as the lower left portion. I need smaller spots on the pulp so I use the edge of my brush and Tone 2 to dab on the sides and edges of each pulp section. I dab Tone 0 into the middle of the sections to represent their sparkling highlights. I then fill in the background with Tone 3.

Fruits: Step 3. I add cadmium yellow light, cadmium orange, ultramarine blue, and underpainting white to my palette. I mix the orange and yellow together in equal proportions and spread this color smoothly and thinly over all the orange peel areas. The resulting color appears slightly dull as I work over the raw umber tones already there.

I take white, add a very slight amount of ultramarine blue and Tone 1 to it and paint this over the white skin portions. Then I mix orange and yellow, with more yellow than before, to paint into the pulp. I take underpainting white and dab it into the pulp sections for the small, sparkling highlights. I combine underpainting white and the color used for the pulp and dab this into the highlighted section of the peel on the right. Then I dab a small amount of white into the center of the peel's highlight.

I add a small amount of blue to my Tone 2 for the shadows on the plate. Also, I blend in white at the bottom of the orange for the reflection of the plate. A bit of blue is added to white for the plate and I'm adding a knife to the composition for design purposes.

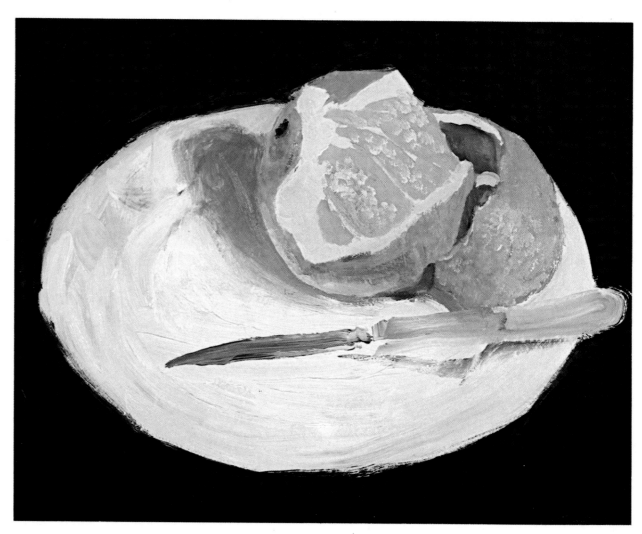

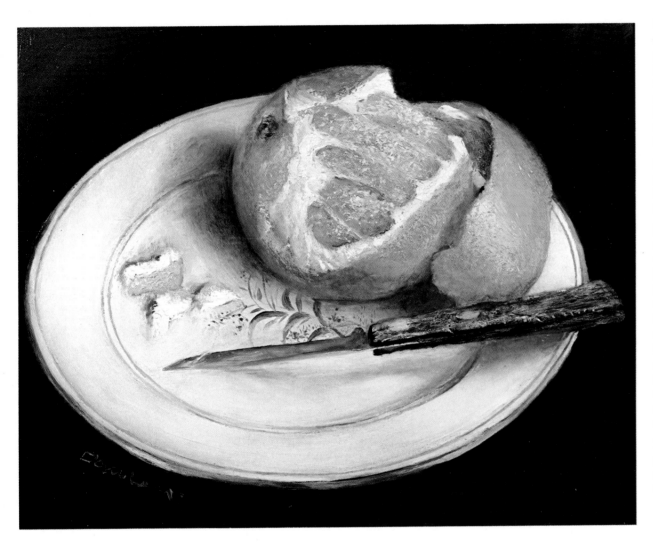

Fruits: Step 4. Yellow ochre is added to my palette. I combine cadmium orange, cadmium yellow, and underpainting white — with a predominance of yellow — and paint this over each pulp section. Then I combine raw umber and ultramarine blue and paint this into the darker portions — such as on either side and on the lower part — of each section, blending well into the orange color. Now I take underpainting white and dab this on over a large portion of each section.

For the lightest portions of the white skin, I combine underpainting white and slight amounts of Tone 1 and blue. For the shadowed parts of this skin, such as seen in the lower left, I use a combination of blue and Tone 2.

I begin the peel by thickly dabbing on a mixture of underpainting white, cadmium yellow, and cadmium orange. Underpainting white and yellow accentuate the highlights on the separate peel. I brush a combination of raw umber and blue into this where shadows occur, such as around the bottom and to the far left. Note that this is blended in on the left side, but breaks off sharply for the cast shadow on the right. The peel is now allowed to dry to a sticky texture. I scumble raw umber and blue lightly over the peel and after this becomes sticky, I scumble again with a yellow and orange mixture. This covers most of the peel, but bits of the raw umber and blue mixture should show through to create a bumpy realistic effect.

I use blue and raw umber for the dark shadow on the plate, extending this under the orange and blending it upward slightly. Raw umber, blue, and yellow ochre are used to paint the navel.

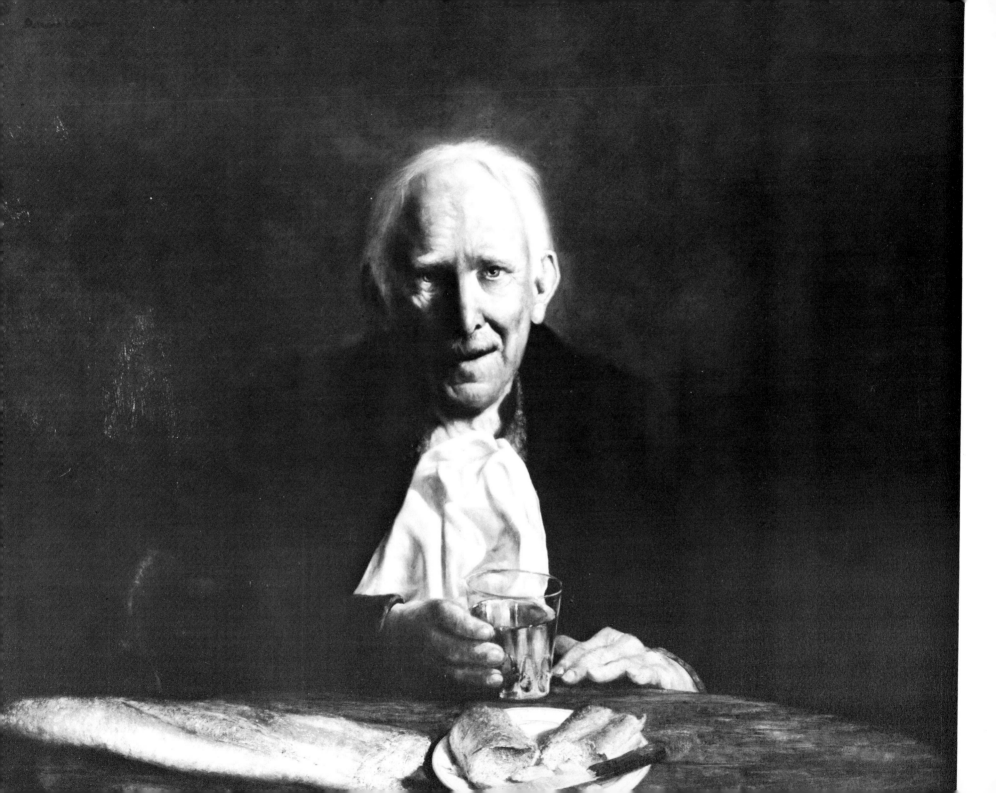

DEMONSTRATION 10
BREAD

Old Man with a French Loaf, oil on Masonite, 24" x 30". The man's obvious enjoyment would be meaningless without the bread and wine on the table in front of him. Displaying both the outer and inner textures of the bread makes a nice contrast to the partially filled glass of wine and the napkin seen through it. Collection Mr. and Mrs. Thomas Stanley.

Bread comes in such a wide variety of textures, shapes, and colors that it was a problem deciding which type to use for this demonstration. I finally set up a still life of two loaves — on the left a brown bread and on the right a rye — providing both interest and comparison. To avoid confusion, however, my demonstration will be limited to the rye bread on the right. The same basic techniques are used on both loaves, with slight variations in color which you can see if you examine them closely.

A good, old-fashioned, solid loaf of bread can be a beautiful prop to use in paintings. In the solid loaves, crust becomes an important element. Both hard and soft crusts are available, but I prefer the hard crusts for their crackling texture and interesting highlights. These highlights are important because they accentuate the natural color of the crust. In any situation, contrast is a truly valuable asset. In crust especially, you'll find highlights give a realistic impression that allows you to almost smell the bread.

If you don't want to work with the whole loaf, you'll find it can be broken in two ways, each

having an interesting effect all its own. One is to rip the loaf apart, which causes the dough inside to have a fluffy appearance. The other way is to slice the loaf, which produces a smoother, more even appearance. I chose sliced bread because I want to capture both detail and texture, and in pulled-apart bread you deal almost exclusively with texture.

The bread details I'm interested in are the various air holes inside the bread. Their location, shape, and size are unique characteristics that require special attention. I've found these holes often flow in a loose, circular pattern, providing the basics for interesting design. Once you recognize the bread's established pattern, you're free to add or delete holes, or vary the size and shape to please yourself and create good design. Of course, there's always the chance that the existing natural pattern cannot be improved no matter what you do.

The texture of bread is difficult to paint well. Don't be discouraged if you don't achieve stunning success with your first attempt. Keep trying — practice can only be of value.

Bread: Step 1. Remember that I'll only be describing my work on the loaf of rye bread on the right. The other bread is being worked on simultaneously for the sake of comparison and design.

I substitute underpainting white for titanium, to be used wherever white is called for. I use Tone 1 to outline the loaf and to outline the inside portion of the bread. The crust is filled in with Tone 2. I now paint Tone 1 on top of the crust on the right side where the light hits it. A combination of Tone 1 and Tone 0 is used for the white portion of the bread and for the board on which the bread is sitting. I use Tone 3 for the background and for the cast shadow on the left which falls onto the other loaf.

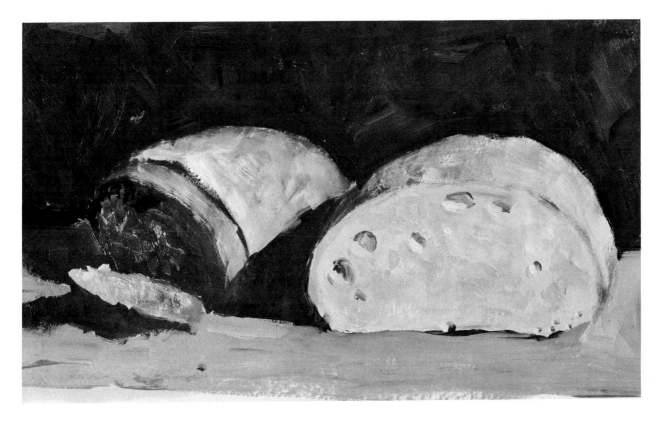

Bread: Step 2. There is a shadow between the board and the bottom of the bread and a stroke of Tone 3 represents this. To begin creating texture in the crust, I scumble white over the entire crust.

Now I begin some basic work on the inside of the bread. First I'll study the general pattern created by the holes in the bread. As usual, these follow a somewhat circular design, so I pick out some strategic holes to indicate this pattern and place them in the bread. I paint a hole by first laying in Tone 3 for the shadow portion, then using white underneath for the highlighted area, and finally outlining the bottom of the hole with Tone 2. I then blend the Tone 2 down into the regular bread color to define the lower edge of the hole.

I first scumble white and then scumble Tone 1 in a random manner over the surface of the bread portion for texture.

Bread: Step 3. I add yellow ochre, burnt sienna, and phthalo blue to my palette. Burnt sienna, yellow ochre, and phthalo blue are mixed for a light brown color I'll refer to as brown Tone 1. I then mix these same colors, only in different proportions, to achieve a darker brown for brown Tone 2.

I begin by adding more holes to the white portion of the bread, in the manner I described in Step 2. I use fewer holes than are present in reality since I want to make sure they're correct in quantity, looks, and location. Next, I mix brown Tone 2 with regular Tone 1 and brush this around in various spots between the holes, still allowing a great deal of the original bread color to remain.

For the crust, I apply brown Tone 2 to the far left side of the loaf and extend this lightly toward the center area. This same color continues as a thin strip down the right side of the sliced edge of the crust. To create the lighter edge on the left side of this sliced section I use brown Tone 1 mixed with white. I use brown Tone 1 for the highlighted middle of the crust. As you can see, I've avoided blending the two colors, instead letting them drag into each other where they meet. For the whole light area on the right side of the crust I dab in a combination of underpainting white and yellow ochre.

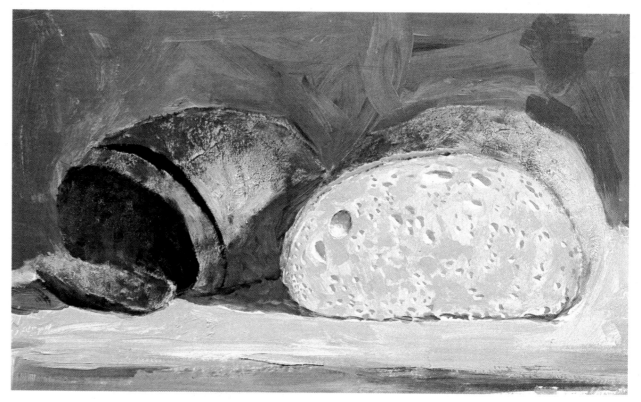

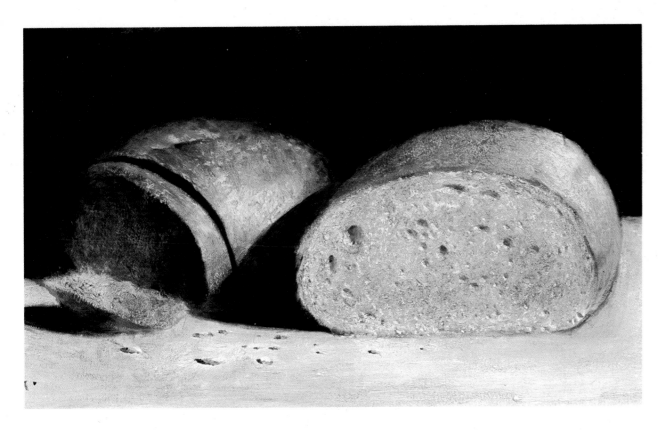

Bread: Step 4. Cobalt yellow, raw sienna, and ultramarine blue are added to my palette. For this step I wait until the paint in the bread portion is almost dry. I then mix brown Tone 1 and Tone 1 together and drag this over the *entire* bread area, toning down both the holes and their highlights. I use this same color to *dab* into the bread for texture.

I add raw sienna to the lower right of the crust and blend this up toward the highlight. The bright spots in this highlight are emphasized with white and cobalt yellow. For texture all over the crust, I dab on a mixture of phthalo blue, cobalt yellow, and white. When the background is dry I paint over it with raw umber and now *I let the entire painting dry completely.* Then I brush painting medium over the entire painting. I complete the crust by glazing raw umber lightly on the far left side and on the edge of the bread portion. Ultramarine blue is glazed into the breadboard and into the shadow to the far left of the bread. To finish the bread, I mix Tone 3 with painting medium until I have a semiliquid consistency. I dip a small sponge into this and dab it over much of the bread portion, this time working around the holes.

Finally, I mix underpainting white with tiny amounts of cobalt yellow and burnt sienna and allow this mixture to become sticky on my palette. Then I scumble this into the bread at random and flick it into various spots for highlights.

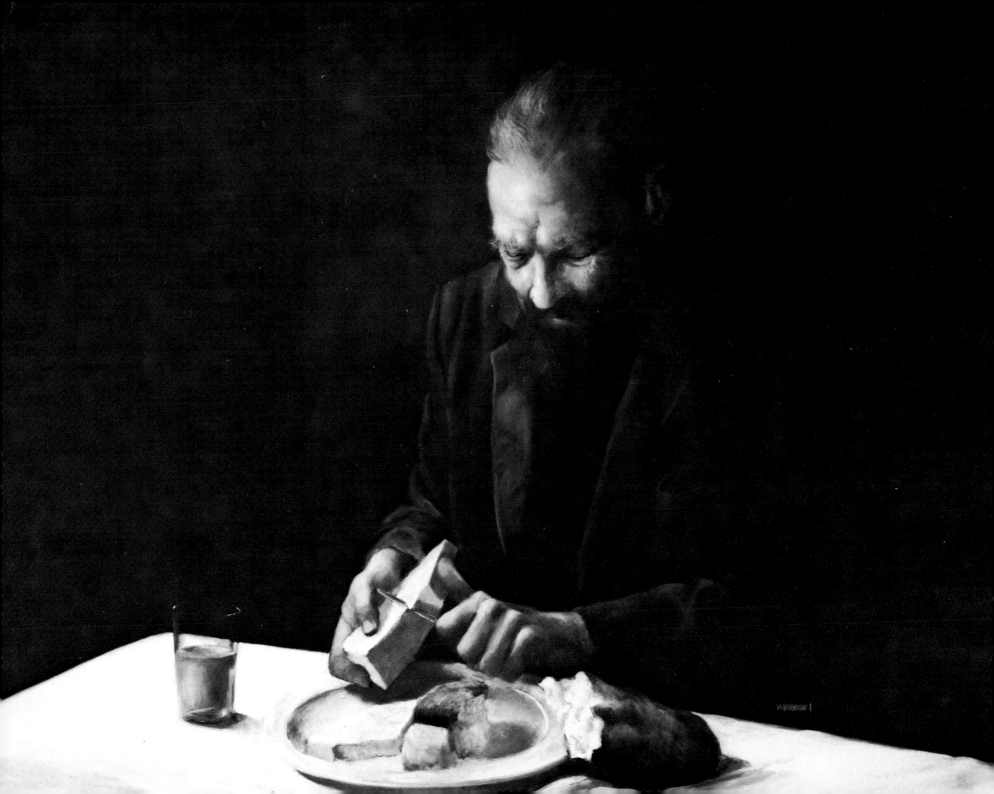

DEMONSTRATION 11
SMOOTH VEGETABLES

Man Slicing Cheese, oil on Masonite, 24″ x 30″. Painting cheese is very similar to painting a smooth vegetable. If the cheese isn't shown in the right consistancy and color, the viewer might not know what the man is cutting and the effect would be ruined. Collection Mr. and Mrs. Robert Sims.

Smooth vegetables are certainly not among the more common items seen in paintings, but should you choose to include them, they must be rendered convincingly. If you decide to arrange your own vegetables, you'll discover a variety of fascinating patterns, colors, and shapes that make smooth vegetables lovely and unique still life subjects. When a category encompasses a large variety of items, as this one does, I feel compelled to narrow my discussion to one or two representative types. For this demonstration, I've selected the turnip and the potato.

As is true of anything taken straight from nature, each vegetable has its own characteristics, size, shape, and color markings. It's this uniqueness that makes a vegetable so inter-esting to portray. In the case of the turnip, you'll want to show the uneven blending of the purple into the white and also the variations of color within the white and dark pitted markings. If you're using two turnips, be sure they are painted in a manner that illustrates their differences. With the potatoes, be sure to include the interesting variations in size and shape. Also take care to vary the size and depth of the indentations on the skin's surface. These unique characteristics combine to form the beauty of each vegetable. Never stereotype each category; treat each vegetable as an individual item.

Smooth Vegetables: Step 1. I start by painting my entire working surface with white. There's no way you can see this in the accompanying photograph, but it's important to know because the white paint will affect both the texture and the color of the paint applied over it.

After this I brush in the outline of each vegetable with Tone 1 and use this same color to block in the areas where the color is strongest. I also indicate the shadow underneath the turnip with Tone 1.

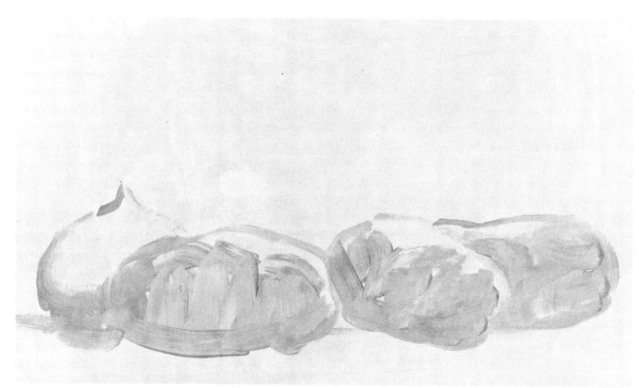

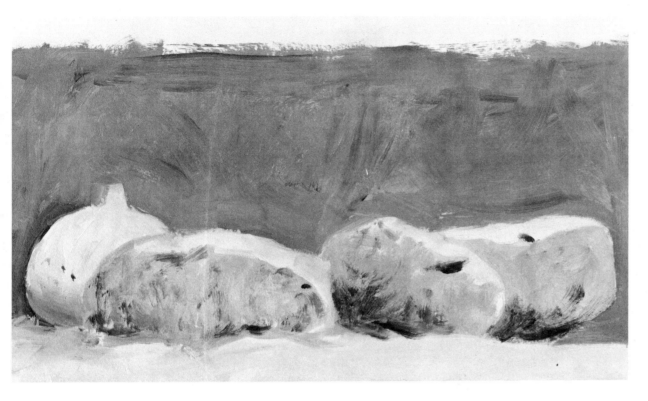

Smooth Vegetables: Step 2. I brush Tone 2 into the top area of the background, but keep the white area below the vegetables to represent the tablecloth.

The Tone 1 applied in Step 1 is now smoothed out just enough to refine the brushstrokes. To further refine the shape of the turnip I apply Tone 2 along its lower edge and then blend this upward into the white, fading it off toward the middle. The two dots of Tone 3 seen near the center complete work on the turnip for now.

On the potatoes, I stroke large sweeping areas of white across the top of each one. To begin the texture of the potatoes, I roughly brush in Tone 2 almost in a scumbling manner. I then scumble in Tone 3 where the color looks darkest and also in the shadow areas on the lower parts of each potato. I dab in Tone 3 for the indentations — such as those in the white portion of the potato on the right.

Smooth Vegetables: Step 3. I add yellow ochre, cobalt violet, Venetian red, and ivory black to my palette. I begin with the turnip and brush yellow ochre into the upper portion of the white area, especially in the center section just below the peaked root. The purple lower portion of the turnip is cobalt violet. Dabs of Tone 2 replace the Tone 3 dots in the white portion done in Step 2.

I use Venetian red for the color of the potatoes and brush it in over the whole surface, with the exception of the top white highlight. Only a slight amount is blended into these highlights for a suggestion of pinkish coloring.

The dark spots and shadows, a combination of yellow ochre and ivory black, are brushed in where needed. I use white with a touch of yellow ochre for the light areas found in the red parts of the potato — for example, the light streak in the middle of the center potato and the brighter highlight on the right side of the potato nearest the turnip.

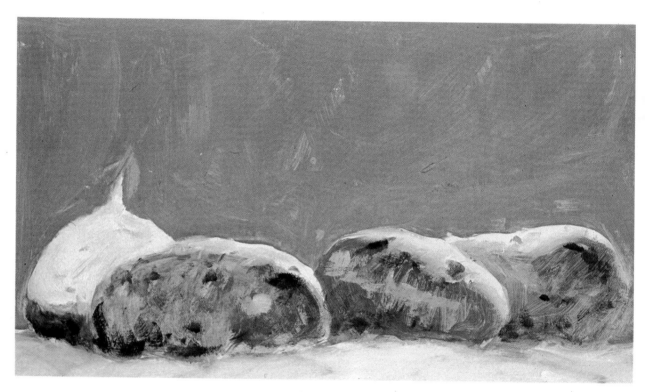

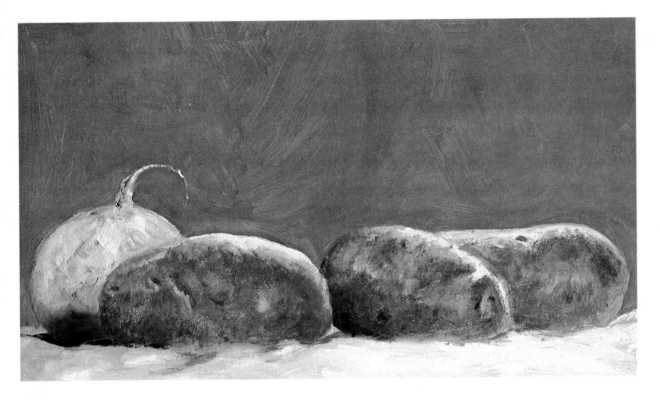

Smooth Vegetables: Step 4. All the elements have basically been laid in and what remains to be done is blending and refining. The additions I'll make here are those that illustrate the dents and rough areas in the vegetables.

I add ultramarine blue to my palette and brush this into my background for color. In the turnip, I add a curl to the end of the root for design. I continue to blend yellow ochre into the white and also brush in a bit of raw sienna in the left center portion. The lower purple color is gradually smoothed upward into the white portion.

The lights and the darks of the potato previously painted in are now blended into the red areas. I use a combination of yellow ochre and black where major dents and shadows appear. I carefully blend the lower shadows upward into the potato to accentuate its form. The highlight color along the tops of the potatoes, for individual highlights on the skin, and for reflections from the dents, is yellow ochre and a tiny bit of black mixed into a great deal of white.

Ultramarine blue and raw umber is what I use for the cast shadows and finishing touches on the tablecloth.

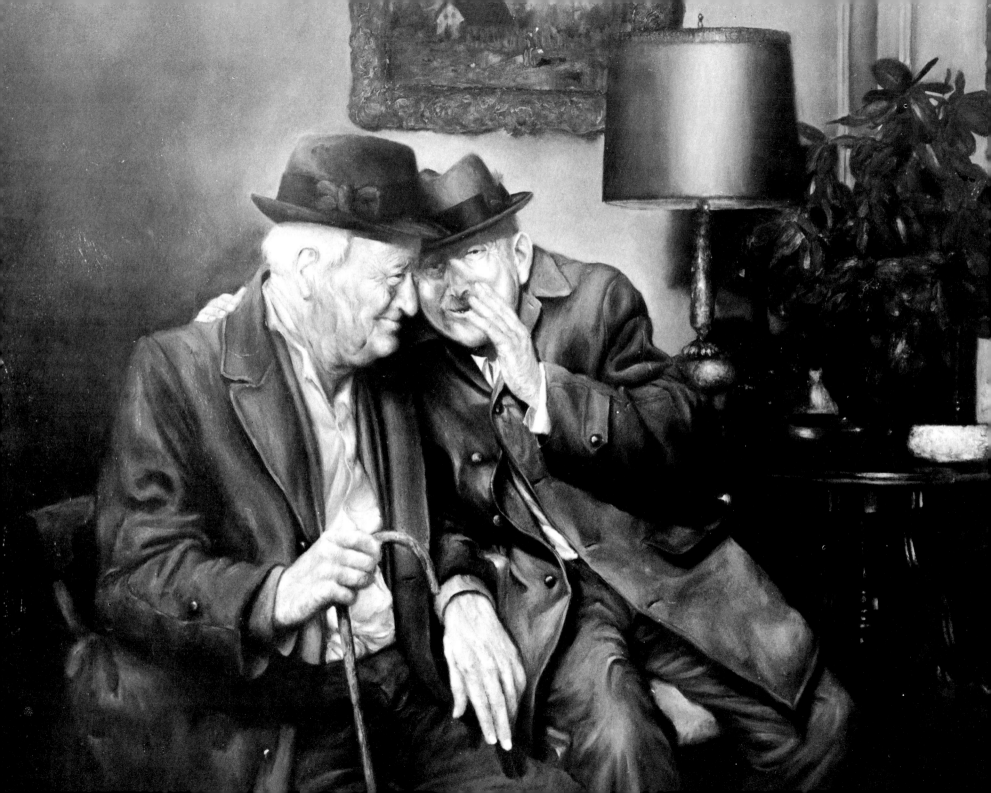

DEMONSTRATION 12
LEAFY VEGETABLES

The Visiting Grandfathers, oil on Masonite, 18" x 24". The magnolia plant on the table serves as a great backdrop. It differs from leafy vegetables only slightly in texture. Collection Dr. and Mrs. Noble.

Leafy vegetables present problems in the application of paint, but don't give you the added worry of having to produce an accurate rendering. In fact, in the beginning, concentration on anything other than location and areas of light and dark can lead to undesirable results. What you're actually trying to render is an *illusion* of the leafiness of the leaves of lettuce surrounding and fanning outward from a solid core. To draw each leaf in separately would produce a harsh and unreal appearance. The accurate positioning of the lights and darks, however, is very important; this lets the viewer create his own image of the positions of the leaves. The technique I'm discussing is a form of impressionism which, done properly, presents an accurate and effective illusion.

As is true with most textures, the use of contrast offers an invaluable tool which can only work to your advantage. In the case of lettuce, the contrast is a natural and ever-present one — the core. One of the nice things about this particular situation is that everyone

is familiar with how a lettuce core looks, therefore, a fairly accurate rendering is really all that is required to convey this contrast. The viewer mentally supplies any details omitted by subconsciously recognizing the difference in texture. Not only does this save you strain and bother, but allows the entire painting to maintain the same loose, impressionistic style.

The final area to be concerned with is the treatment of the outline of the lettuce. As you look at it, the perimeter will appear sharply defined, however I prefer to soften all the edges to keep them in the same style as the rest of the painting.

My method is certainly not the only way to paint lettuce or other leafy vegetables, but I find it practical, relatively uncomplicated, and rewarding.

Leafy Vegetables: Step 1. My aim is to block in the general areas of tonal value and due to the flexible nature of lettuce, this can be accomplished in a very loose manner.

I begin by brushing over the entire painting surface with Tone 1 thinned with turpentine. All my painting will be done over this tone.

I use Tone 0 to represent the core of the lettuce providing a reference point from which to paint in the leaves. I then dab in Tone 2 to represent the major shadows appearing in various areas among the leaves. Tone 1 is used to represent the actual leaves and is dabbed in as a filler between the areas of shadow. The large shadow to the left of the lettuce is Tone 3.

Leafy Vegetables: Step 2. All areas of the subject must now be more precisely defined, and I begin by using Tone 1 to paint in the wavy outline of the lettuce. To provide contrast, and to see exactly what's happening in the lettuce, I've filled in the background with Tone 2. I tone down the white of the core by lightly brushing a small amount of Tone 1 into it. The dark accent lines within the core are Tone 2.

The leafy portion is enhanced by adding some middle tones to supplement the colors already there. White is brushed around at random and allowed to mix with the Tone 1 to create some light areas. Tone 1 is allowed to remain in sections and becomes a middle tone. I then work around and refine the darker shadow areas of Tone 2 in the leaves. I use Tone 3 for the large shadow on the lower left.

Leafy Vegetables: Step 3. I add cadmium yellow light, raw sienna, phthalo blue, and burnt sienna to my palette. I begin by mixing my blue and yellow together for the light green in the major portions of the lettuce leaves. I mix a darker green by adding more blue and a dab of raw umber. The darkest green seen in the shadow areas is the same as the above combination, but with more raw umber added.

These three greens are brushed in using rough strokes and no attempt is made to blend them. I swirl, dab, and stroke my brush to achieve the proper loose, fluffy impression. If I find I need some lighter areas — such as on the top or on the right side of the head — I add a stroke of white.

A very slight amount of my lightest green is brushed into the upper portion of the core. The rust color in the core is burnt sienna and I use raw sienna to paint in the background. The large shadow to the left, and underneath the lettuce, is raw umber.

Leafy Vegetables: Step 4. For esthetic reasons, I've decided to add some leaves in the lower right and upper left areas that will stand away from the lettuce. I expand my palette with underpainting white, cobalt yellow, and viridian green.

First I take underpainting white and brush this into the leafy portions at various intervals. I cover the leafy area in a random manner, allowing the underpainting to be frequently exposed. I've left a large area exposed on the left side where many important crevices are located. I wait until the underpainting white becomes sticky, then I mix viridian green and cobalt yellow to produce a light green which I scumble into the white. The entire painting is now allowed to dry, then brushed over with painting medium.

I finish the background with a combination of black and raw sienna. I again accentuate the cast shadow with raw umber and the rusty areas of the core with burnt sienna. Next, the outer edges of the head are softened by brushing out into the background with a combination of cobalt yellow and viridian green. I also flick viridian green into the leaves at various points to produce touches of bright color.

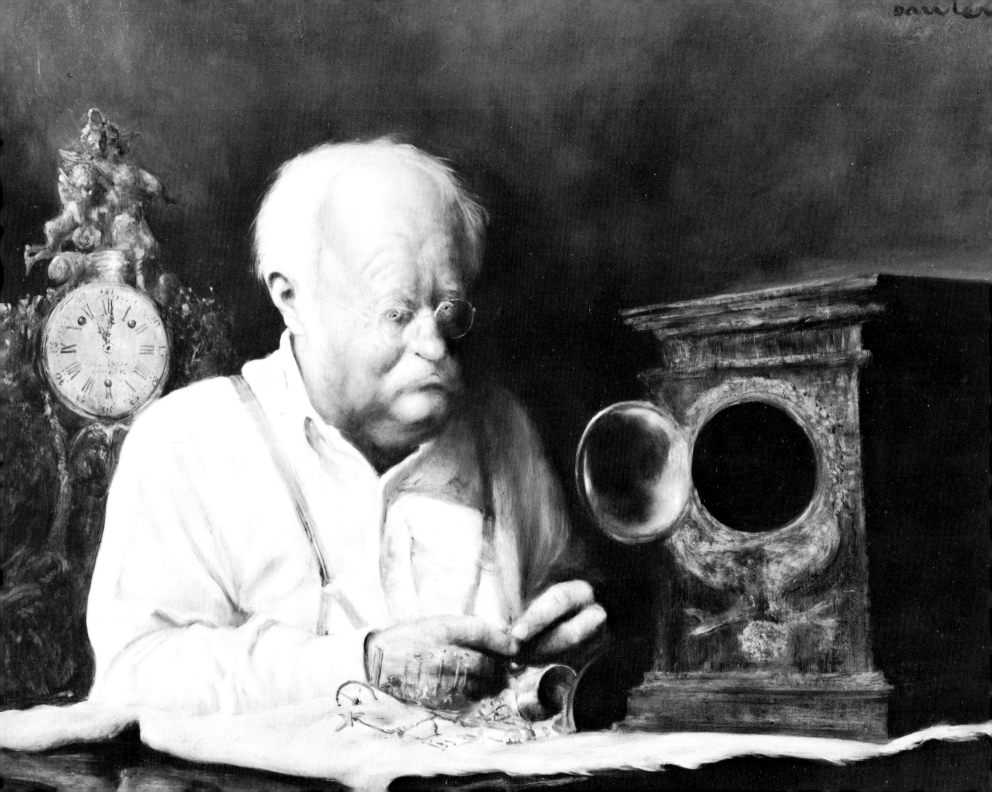

RUST

Fixing the Clock, oil on Masonite, 21'' x 28''. The main part of the clock in this painting is wood, but the metal ornaments on parts of the case are rusted. This rusting indicates age and intrigue, setting a mood. Collection Dr. and Mrs. R. Hartkopf.

Rust is one of nature's underrated creations; it's a remarkably beautiful and often overlooked enhancement to a painting. Although the occasions in which rust can be appropriately used in a painting are few and far between, when it can be incorporated, lowly rust easily becomes a main focal point. The powdery, rough texture of rust against the shiny surface of metal provides both contrast and complement. This element of contrast is important for more than esthetic reasons; it *must* be present in order to paint a believable impression of rust. If enough distinguishable contrast isn't present, the viewer's ability to relate and identify is diminished to a surprising degree. It may be rust to you, but to others you'll have created a nice orange object. The technique I describe in this demonstration allows you a great deal of control over the amount of rust to be displayed, so it's definitely important not to overdo it.

The color of rust is so typical and well-known that we tend to think of it as one specific color. Basically it is, but when you start to paint it, you'll realize that there are many values created by the proximity of the basic color to the metal. The color variations depend on how heavily rusted a particular area is; the less rust, the closer the color is to the natural color of the metal. This is why I chose to actually "rust" the object by painting *over* the base color where desired. I find this technique allows me the variety of rust tones actually found in nature.

Rust: Step 1. Due to the texturing requirements of this subject, I substitute underpainting white for titanium white on my palette. I'm not going to discuss the painting of the bucket in this demonstration, because I feel it was adequately covered in the discussion on how to paint wood in Demonstration 8.

With Tone 1 I draw in the general shape of the bucket and metal mechanism. My primary concern is proportion and shape. The dark, shadowed interior of the bucket is Tone 3 which is tempered with Tone 2 in the lighter portion on the right side.

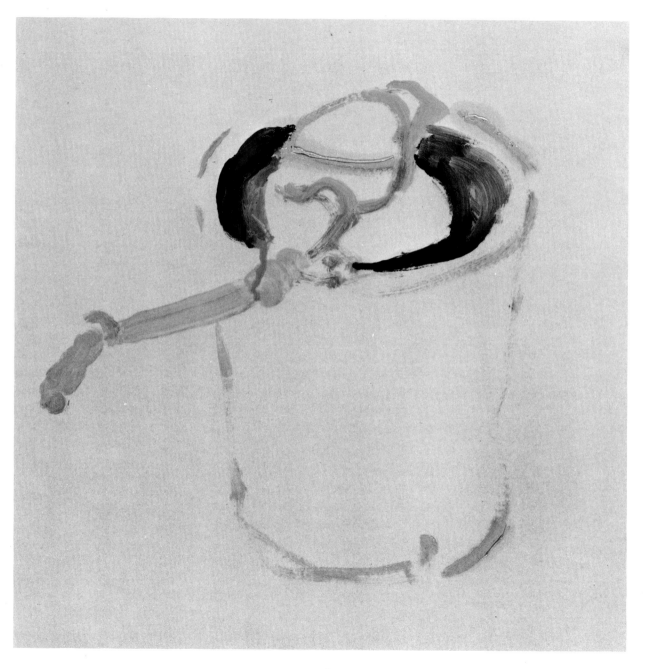

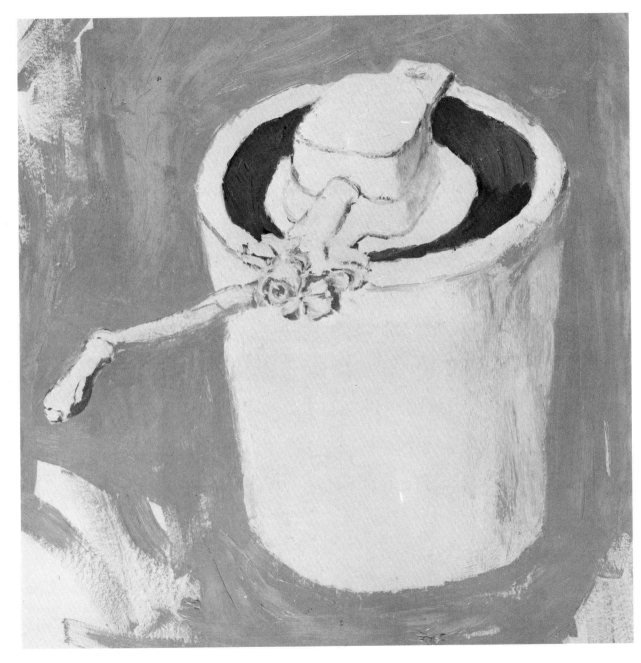

Rust: Step 2. My prime objective is an accurate and workable contour drawing to provide the basic groundwork for the subsequent layers of paint.

Tone 2 is used to define and outline all the shapes. I then fill in all the defined areas with Tone 0, brushing it on thickly because it's needed for a texture base in both the wood and the metal.

The shadow on the right side of the bucket is added by brushing Tone 2 into the Tone 0 in this area. For the shadow found on the right-hand sides of the two metal rectangles, I use Tone 2 again. Tone 3 is placed along the lower edge of the handle, both to indicate form and maintain separation from the background. The entire study is surrounded with Tone 2.

Rust: Step 3. I add raw sienna and ultramarine blue to my palette. I want to use a slight scumbling technique in this step, so I let the paint sit a short while until it's slightly sticky. The objective is to paint in the black color of the metal as if it were free of rust and then paint the rust on top of this. For my black, I mix raw sienna and ultramarine blue and brush it in on top of the underpainting white. It should be darker in some areas and lighter in others. In spots where there's a heavy concentration of rust I allow the white to remain exposed. The variations between the white underpainting and the black metal color will cause desirable color variations in the rust when it's applied. A combination of raw sienna and raw umber is used for the wooden handle. Tone 4 is brushed into the background where the cast shadow is found on the right side.

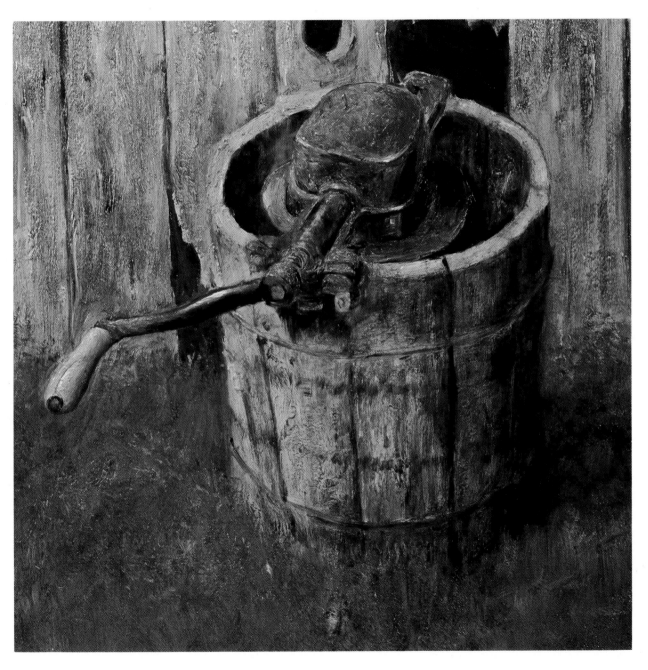

Rust: Step 4. I add burnt umber, burnt sienna, Venetian red, and cobalt yellow to my palette. I mix burnt sienna and underpainting white into a rather dark rust color and *lightly* scumble this into the rusted areas, leaving portions of the black exposed. I redefine the black where necessary for design purposes.

For the lighter shade of rust I mix burnt sienna, Venetian red, and cobalt yellow together and scumble this in where needed. Scumbling these two rust shades is very important since this method allows the underpainting to create various shades of rust.

For the deep shadow areas of rust — such as in the crevices and joints of the metal — I use burnt umber. For the highlights reflecting from the black part of the metal I use white. I then mix burnt sienna and white together for the duller, rusty highlights.

DEMONSTRATION 14
OLD BOOKS AND PAPER

Rare Find, oil on Masonite, 21" x 31". This book isn't as old as the family Bible in the demonstration that follows, but its character is still evident in the old stamps and the handwrought lettering on the pages. Collection Mr. Frank Battle.

Old books and paper are demonstrated together not only because they're painted in a similar manner, but because of the obvious connection they have to one another.

Painting the book cover poses problems very similar to those found in painting old leather (Demonstration 15). The obvious elements of wear are present, with portions of the cover design or color partially or totally eliminated through constant use. Because of this, the lower textures of the cover are exposed in varying degrees, creating interesting colors.

Even though the rendering of the book's cover is important, it's by no means the key to showing the aging process of this lovely item. You must make absolutely sure that no one confuses your lovely old book for one that has simply suffered disgraceful abuse. I therefore feel it's important to include as many characteristics of obvious aging as possible. Two

such characteristics are the battered binding of the book and the worn bottom edge of the cover. Watch for these points of interest when selecting a subject to paint; they add immeasurably to the overall impression.

My particular book presents another bonus in the pages that are falling out. This not only helps me convey the age of the book, but also gives me enough exposed paper with which to illustrate technique. I want to give the *impression* of old pages, painting just enough individual pages to insure clarity. Unless you're dealing with just one piece of paper, I feel it's a mistake to try to single out individual pages. Try, rather, to capture the illusion of many pages, working in large, general areas and avoiding meticulous rendering.

Old Books and Paper: Step 1. Because of the textural requirements in this demonstration, I use underpainting white exclusively on my palette. With Tone 2 I outline the shape of the book and sketchily fill in the cover and pages. To show the wear on the lower edge of the cover, I brush Tone 0 between two lines of Tone 2.

Notice that I haven't shown the pages protruding from the side of the book. I've used a linear pattern of pages in a natural relationship to help me be accurate in proportion and perspective. I deleted the bookmark in this step for the same reason.

Old Books and Paper: Step 2. The book cover is Tone 2. The torn binding on the far left of the cover is indicated with Tone 4. Tone 2 is then added to the far left of the Tone 4. The large shadow between the binding and the pages is also Tone 4.

I now locate the ragged pages falling out of the book with streaks of Tone 0. The shadows of these pages and the shadow cast on the table are Tone 3. It's important to brush Tone 0 thickly into all the areas where paper is showing. This provides a texture base on which to build.

The marker is Tone 0 with Tone 2 brushed into it. Tone 2 is used for its shadow cast onto the pages and to give the vague indication of the table.

Old Books and Paper: Step 3. Yellow ochre, Venetian red, ultramarine blue, and cobalt violet are added to my palette. The entire surface of the book cover and the bit of binding to the far left are scumbled over with a combination of ultramarine blue and raw umber. I solidly brush this same color into the dark areas of cover design, such as the lines radiating from the center design.

I very lightly scumble yellow ochre into the ragged bottom edge of the cover and into the paper to produce the yellowish, aged appearance of these areas. Venetian red and white are used in varying degrees of strength for the marker.

I brush in the tablecloth with a combination of yellow ochre, raw umber, and white. I next blend the large cast shadow on the tabletop into the cloth color. I also refine the cast shadow on the side pages and more clearly define the shadows between the falling pages. The neutral tone used to paint in the background is a combination of yellow ochre, white, cobalt violet, and ultramarine blue.

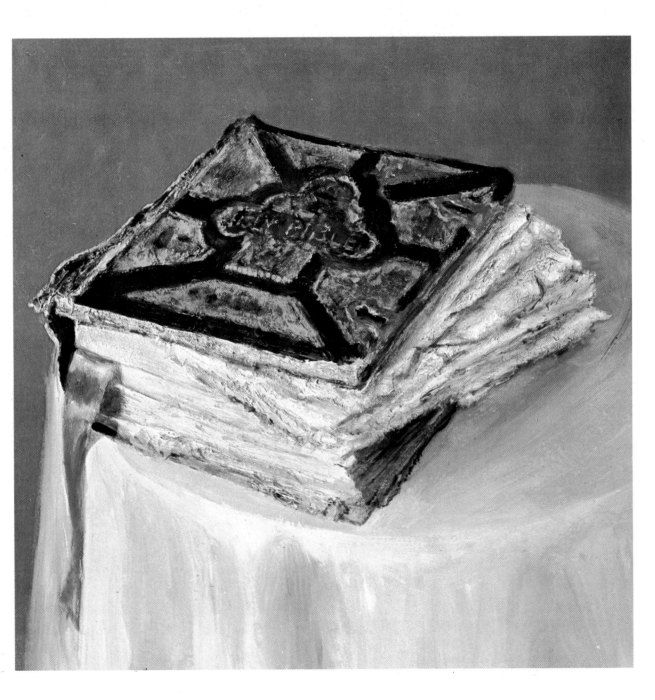

Old Books and Paper: Step 4. I add burnt umber to my palette. The yellowish color of the cover design is created by a random scumbling of cobalt yellow, sometimes mixed lightly with burnt umber or with burnt sienna. The keyholes on the right-hand side are surrounded by a combination of burnt umber, burnt sienna, and cobalt yellow. In the center cover design, I use a # 2 watercolor brush for precision work, such as laying in the dots of cobalt yellow along the bottom edge.

The final aging effects of the pages and raw edges of the cover are painted with raw umber and burnt umber. These are lightly scumbled in at random, but occasionally used to define the ragged edges of pages. I mainly use burnt umber, reserving raw umber for the vague shadowy areas.

I use raw umber for the shadow to the right of the marker. Notice that the impression of loose pages is achieved by breaking the descending line of the shadow. The shadowed lower pages on the side of the book are defined with raw umber and burnt umber.

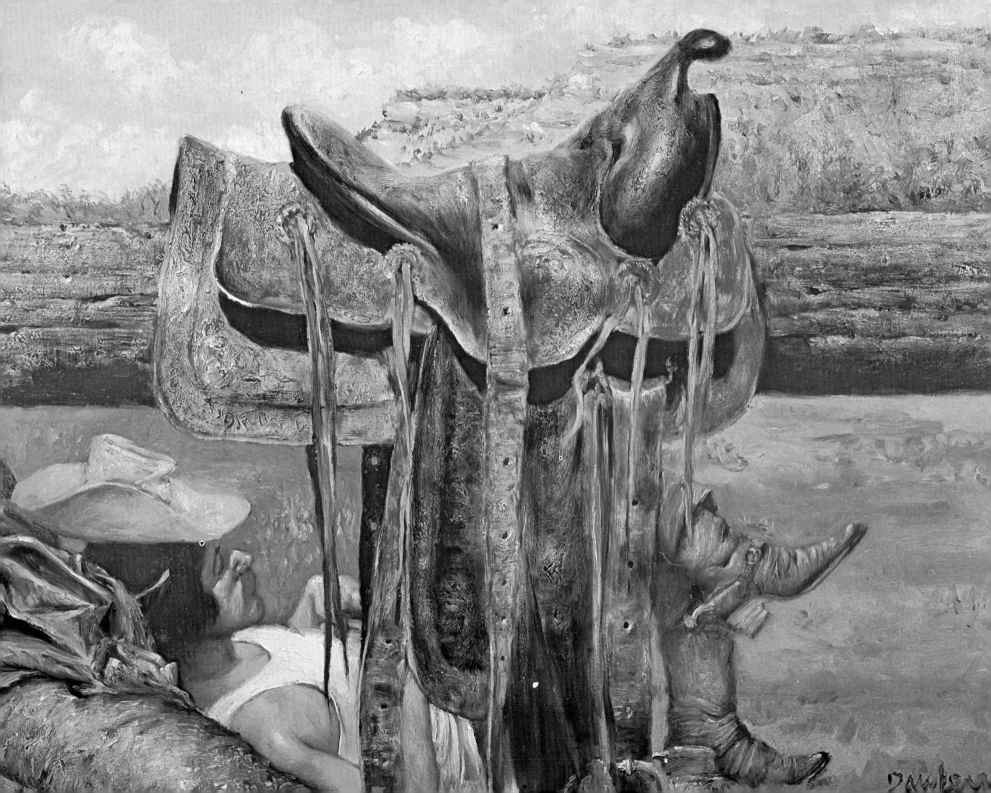

DEMONSTRATION 15
WORN LEATHER

Siesta, oil on Masonite, 11-1/2" x 16". Notice how the saddle loses a great deal of importance when a figure is introduced into the picture. Because the saddle is in the foreground however, it's important to give the viewer the feeling of old leather. Collection of the artist.

The differences between new, shiny leather and worn leather are so vast that it's difficult to always remember that the basic material is the same — only the surface treatment is different. The leather color is pure in shiny leather, partially dulled in worn leather. Reflections are a natural part of shiny leather, but they are nonexistent in the worn. Highlights are brilliant and sharply defined in shiny leather, but quite dull — if apparent at all — in the worn.

The very term "worn leather" is ambiguous because the degree of wear varies; it may be extreme, hardly perceptible, or average, and each maintains a characteristic appearance. When the degree of wear is minimal, some of the original surface sheen and color will be mixed with the worn, paler areas. This provides contrast in both color and texture. The color is on the surface of the leather, therefore, the more worn it is, the paler the color and the duller it will be.

There will be great variations of surface composition and texture in the item you choose to paint. I find a painting technique similar to the one I use to paint wood best suited to painting leather.

This demonstration veers from the norm in two respects. First, I've created an entire scene in the fourth step because I thought you might find it interesting to see how a subject can evolve into a painting. Secondly, not being an equestrian, I'm totally unfamiliar with the nomenclature of saddle parts. My reference source refers to "seat," "cinch," "horn," "saddle," and "flaps." I've isolated the seat portion as an entity and refer to it as the "seat." The flat portion underneath the seat which rests directly on the horse's back is the "saddle," and the "flaps" are the large leather pieces hanging from each side of the seat. The "cinch" is the long leather strap hanging over the seat, and the "horn" is the round handle on the front of the seat.

Worn Leather: Step 1. Underpainting white is used throughout this demonstration. I use thinned Tone 1 to outline the general shape of the saddle and to fill in areas of middle value. I leave the lightest (white) areas unpainted. Tone 4 is used for the very darkest shadows.

For details on how to paint the wooden fence rail that the saddle is sitting on see the discussion on painting wood in demonstration 8.

Worn Leather: Step 2. The rear portion of the seat, to the painter's left, is slightly darker than the front section and I indicate this darkness with Tone 2. Highlights — such as on the back of the seat — are Tone 0.

The right side of the seat, which is lighter in value, has a great deal more Tone 1 in it. I use Tone 2 for darker areas, such as those on the lower right of the cinch and below the horn. Highlights — such as the large swirl in the lower half of the seat and those on the horn — are Tone 0.

The saddle is almost completely Tone 1, with highlights of Tone 0. I use Tone 2 occasionally to emphasize certain areas, such as the shaping in the lower left and the buttons securing the saddle strings. Tone 1 is used for the flap.

111

Worn Leather: Step 3. In this step I lay in the basic groundwork for the final color rendering and for the creation of texture.

I add phthalo blue, Mars yellow, and burnt sienna to my palette, and wait until my paint has become quite sticky before I begin painting. Phthalo blue and white make up the temporary background.

I mix burnt sienna, Mars yellow, and phthalo blue for the brown color. I also mix Mars yellow and white to produce a yellow. What I do now appears quite complex to the eye but is actually relatively simple. The brown tone is applied both in a brushy manner (using thick brushstrokes) and a scumbling manner. I brush it into areas requiring a darker, browner appearance — such as to the right of the flap. In the paler areas I use the scumbling method, allowing the brown to skip along the top of the underpainting. Next, I take my yellow mixture and scumble this on top of the brown: this is done heavily in the lightest areas, lessening where the brown deepens, and omitting it entirely where I need dark brown. The highlights are the yellow mixture brushed on solidly. This is seen clearly on the cinch, which because of its worn surface is painted much like a highlight.

Worn Leather: Step 4. Raw sienna and burnt umber are added to my palette. I allow Step 3 to become completely dry before I apply painting medium to the entire surface. To achieve a creamy texture in my paint, I dip my brush constantly into a cup of painting medium as I work.

In the deeper brown areas — such as the seat and the flap — I overpaint with a reddish brown mixture of burnt sienna, Mars yellow, and phthalo blue. I don't apply this evenly, but brush it in according to how deep I want the color to be. The brown is brushed up into the highlights and carefully blended to produce rounded forms in areas such as below the horn. Raw umber and burnt umber are brushed in for texture and to define form. I brush raw sienna into the cinch and use raw umber in horizontal strokes to create texture.

Since the saddle is lighter in color, glazing is done very sparingly with raw umber, raw sienna, and a little burnt umber. Notice that my brushstrokes are diversified in direction, again for the purpose of creating texture.

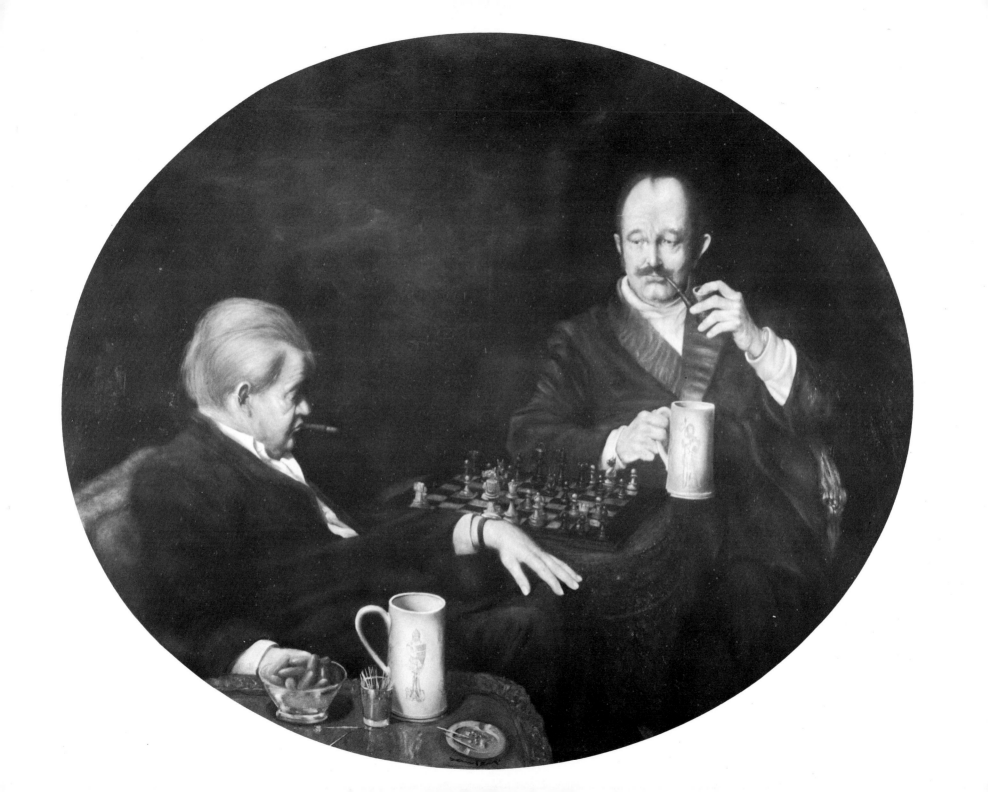

DEMONSTRATION 16
POTTERY

Chess Players, oil on Masonite, 31" x 37". Whereas a checker game in a painting conveys a plebian mood, a chess game conveys a very aristocratic one. Notice how the porcelain beer mugs and the lavish housecoats of the men carry the atmosphere even further. Porcelain is a little finer than pottery and much shinier. Private collection.

Pottery refers to any item made from clay and hardened by fire. It can progress in complexity from a rough crock all the way to fine china. The definition of the term offers a wide variety of textural differences so to limit my subject I'm going to deal only with claylike, unglazed forms of pottery. For the glazed, reflective variety refer to the discussion on painting china in demonstration 19.

In this type of pottery, there are three main concerns: texture, form, and color. Texture is one of the main points of beauty in pottery. The piece I've selected has soft color variations, and although it's hard to the touch, it's soft in appearance. It's this rough but soft appearance that I want to capture. To do this I use soft, low-keyed colors. I apply them in a random manner, either blending or scumbling so that nothing appears harsh.

The form of the pot must be rendered by shadows alone. It's a flat-toned surface, with no highlights to help you create form. It's therefore important that you be conscious of the form shadows from the beginning. The high spots may be flooded with light and therefore lighter in color, but this can't be portrayed as a highlight or it would convey a hardness totally unlike pottery.

Pottery: Step 1. I use underpainting white exclusively for this demonstration. My aim is to capture the general shape, basic tonal values, and most important, to lay the foundation for the great amount of texturing necessary in later steps.

I use Tone 1 to draw in the general outline. I then apply underpainting white thickly to the entire exterior of the pot. Next I apply Tone 2 into the large form shadow on the far right side of the pot, brushing this into the white. The dark inner portion of the pot is a combination of Tone 1 and Tone 2.

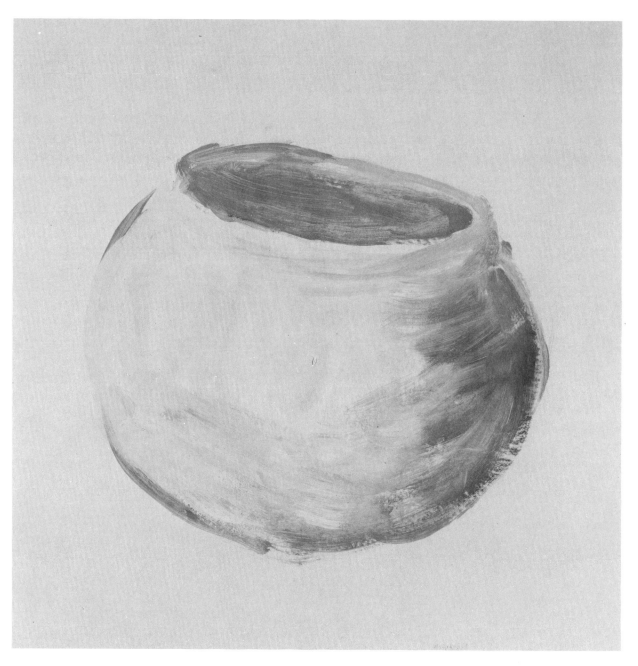

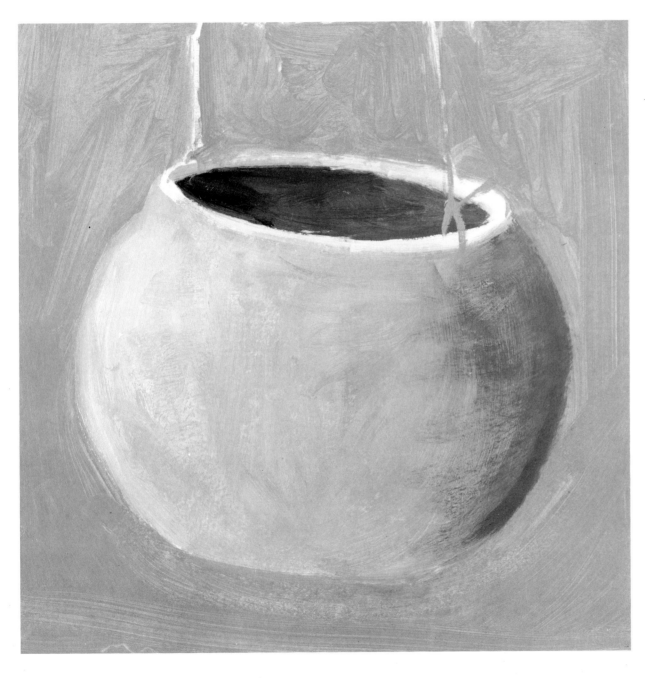

Pottery: Step 2. In this step I'm interested in perfecting the shapes and values especially developing the roundness of the pot. I do this by brushily applying a combination of Tone 0 and Tone 1 on the far left, Tone 1 in the center, a combination of Tones 1 and 2 on the right, and Tone 3 on the far right-hand edge. By roughly blending all these together, I achieve a round effect.

The lip of the pot is Tone 0 on the right and Tone 1 on the shadowed left side. The dark inside portion of the pot is Tone 4 on the left and Tone 3 on the right. Again, these are blended together in a rough but uniform manner.

A line of Tone 1 and a line of white next to it are used for the supporting wire. The background is Tone 2.

Pottery: Step 3. I wait until Step 2 is quite sticky before beginning this step. I also want the underpainting white to sit on the palette until it becomes somewhat thick and sticky. It will be used in a scumbling manner to create texture.

Using the edge of a 3/8" flat brush, I streak the white across the pot, using a scumbling approach. To vary the texture, I frequently bear down a little harder with the brush allowing the paint to blend with the underpainting, rather than skip along the top of it.

I emphasize the dark edge on the far right of the form shadow by streaking Tone 4 along the edge of the pot in the pattern already established. Tone 4 is also used for the hole for the supporting wire.

I again wait for the painting to become sticky. I mix Mars yellow, ultramarine blue, and white to use for the background and to brush lightly into the pot on the far right. I now mix Venetian red, Mars yellow, and white together and scumble this across the pot with a 5/8" brush. At times I use more yellow and at times more red to give color variation. I take this same combination and brush it into the dark inside of the pot and also lightly along the shadowed left-hand edge of the lip.

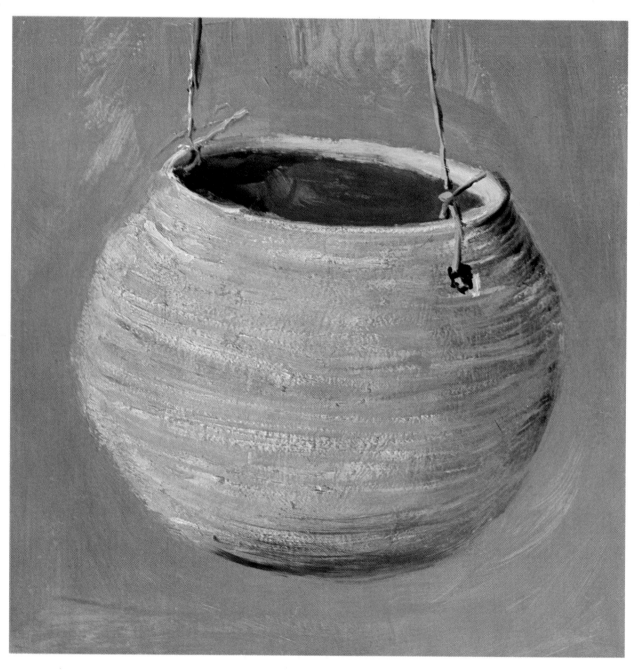

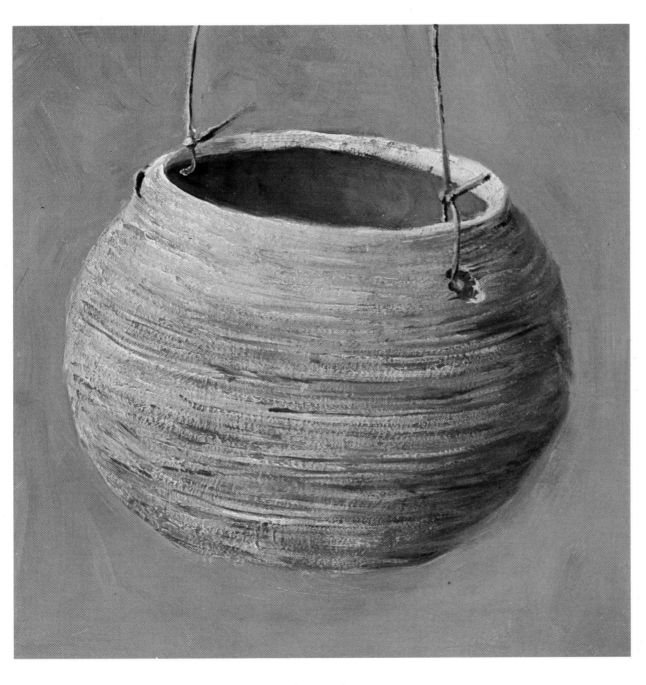

Pottery: Step 4. I mix ultramarine blue, Mars yellow, and Venetian red into a brown and streak this across the pot. I combine streaking and scumbling techniques to provide the characteristic variations of texture in the pottery. I work with a 3/8" or 1/4" brush, varying pressure so at times the paint scumbles across the top, at times blends with the underpainting.

For the dark inside of the pot, I paint raw umber into the left and a combination of Venetian red and Mars yellow into the right. I then blend these softly into each other. This mixture of Venetian red and Mars yellow is also scumbled into the lip. The light portions of the lip are a combination of Mars yellow and lots of white.

I continue brushing the background color into the right side of the pot in a streaking manner, which retains the mood and feeling of the pottery.

SHINY LEATHER

The Clock Connoisseur, oil on Masonite, 28-1/2" x 32". The shiny leather of the gentlemen's shoes is the only element that keeps the bottom of this painting from being lost in total darkness. Yet the shoes are so effective that the viewer might think he sees the whole form of the legs and everything going on at floor level in the clock shop. Collection of the artist.

Shiny leather is unique because very few steps are actually required to portray it. It's possible to create an impression of shinyness even in the simplest form of a black and white cartoon by merely placing a sharply defined white highlight on a solid black shoe.

Black seems to be the most common color of shiny leather, so I'll use a pair of black boots for this demonstration. Any other color, however, would be dealt with in the same manner.

Shiny leather is just like any other hard, dark, reflective surface in that reflections of surrounding colors bounce off it. These appear muted, and I blend them in my painting since they're not prominent points of interest. Although the surface reflects these colors just as sharply as it does the white highlights, the tremendous contrast between the black and white dictates that the white highlights be left in an unblended state.

Creases and wrinkles are permanent features of shiny leather and it's important to capture the highlights on top of their folds accurately. It's a temptation to sweep in several strokes of white and allow this to represent creases, but leather does not wrinkle uniformly and care should be taken to represent the actual shape and location of the folds.

Leather isn't a particularly difficult or complex topic so it's especially suited to those anxious for good quick results.

Shiny Leather: Step 1. I want to roughly capture the movement of the legs and the characteristics of the boots by indicating the major areas of folds and also making sure that the feet are pointing correctly in relation to the legs.

The first thing I do is brush Tone 1 over the entire background. Then I use Tone 2 for the outline of the boots and legs and to indicate the location of the larger fold areas.

Shiny Leather: Step 2. At this point I want to block in the major tonal values. I'm not concerned now with the subtle tonal variations, and you'll note that I merely brush in these values without blending.

I use Tone 3 for the darkest portions of the boots, such as on the back of the calf. Most of the boot area is Tone 2 and I come back over that with strokes of Tone 1 to indicate the wrinkles in the leather. Tone 0 is dabbed on in the spots of brightest highlights. The skin tone is a combination of Tones 0 and 1, with the shadowed portions — such as behind the knee — indicated with Tone 2.

Shiny Leather: Step 3. I now want to lay in the basic colors appearing in the leg and boot, roughly brushing them into their proper locations with no blending. Ultramarine blue, yellow ochre, and Venetian red are added to my palette.

I combine ultramarine blue and raw umber with a touch of white for my basic black color. As I brush this on, I naturally pick up some of the underpainting. This creates the slight variations of color like those on the calf area of the left boot. Notice that my strokes follow the angles and lines of the creases, which helps create the look of the folds.

The brown of the floor is a combination of blue, yellow ochre, and red, with the emphasis on yellow ochre. I use this color in various spots on the boots where the floor color is reflected. The darkest spots on the boots are a combination of blue and raw umber, applied thickly enough to obscure any underpainting. I use white for the light highlights.

Shiny Leather: Step 4. The first thing I do is complete the floor with the brown described in Step 3. Then I finish the background with a combination of yellow ochre, ultramarine blue, and a tiny bit of Venetian red. Notice the variation of tone and color as I paint over the existing Tone 1, producing a new background color.

I now add ivory black to my palette and paint this into the very darkest portions of the boot. I allow the underpainting to be exposed wherever necessary, such as in the crease areas and areas of reflected color.

I next brush a touch of blue into each highlight. The very brightest spots — such as the toe of the right boot — can then be emphasized with white. Sparkling highlights are characteristic of shiny leather, so be sure not to blend them.

DEMONSTRATION 18

BEVERAGE IN A GLASS

Rathskeller, oil on Masonite, 16" x 25". No drink in the world is as jolly as beer. And the foam on the top makes it look as delicious as it tastes. Even if you don't care for beer, you can share the sense of pleasure conveyed here. Private collection.

Beer is a fascinating and beautiful subject; it has a glowing, rich color and a translucency that tends to reflect the surrounding lights and shadows.

What makes beer really interesting to paint, however, is the thick layer of foam on top of the liquid. When the glass is tipped this foam, thick and frothy, clings to the sides and is one of the effects I want to capture in this demonstration. I won't try to paint the exact patterns the foam has created on the glass, however. The foam doesn't last forever and by the time the painting is partially finished, the patterns will have changed. One can, of course, try drinking a little each time the foam evaporates and then pour a little more — however this procedure not only promotes sloppy work after many hours of painting, but can cause a severe headache the following morning!

I prefer taking a splashy, casual approach to painting beer instead of duplicating it exactly. A beautiful effect is all you're after, and since beer is a moving, ever-changing substance, you should use these characteristics to your advantage. Use what you see as a guide and embellish if it fits your sense of design. Keep in mind, though, that the foam clings to the glass sparingly, so over-embellishments will be harmful to the effect.

I've chosen to incorporate some reflections in this demonstration that may differ a bit from reality, but I feel they're representative of reflections on a shiny surface. An actual reflection is a strict duplication of the object reflected, but I prefer to blur the elements in the reflection while still maintaining accurate proportions. This distortion of the actual object allows the viewer to recognize it as a reflection rather than as an object. The beer mug in this demonstration has a pattern of indentations in it to illustrate some of the problems of painting patterns in glass.

Once you've mastered painting a beer mug, you'll probably find it a useful prop to include in your paintings.

Beer: Step 1. In this step my primary interest is to capture proportions. I take Tone 1 and paint in the area of the mug that is filled with beer. Above this I use Tone 0 for the thick layer of foam. Above the foam I use Tone 1 again to fill in the remaining portion of the mug. The edge of the rim is indicated with Tone 0. I bring Tone 0 down in spots — such as seen to the far left and far right — where beer foam is dripping.

I use Tone 1 for the handle, the reflection of the mug on the table, and the horizontal line representing the table edge. I use Tone 0 to indicate the bottom of the mug. At this point it's not necessary to do anything with the indentations in the glass.

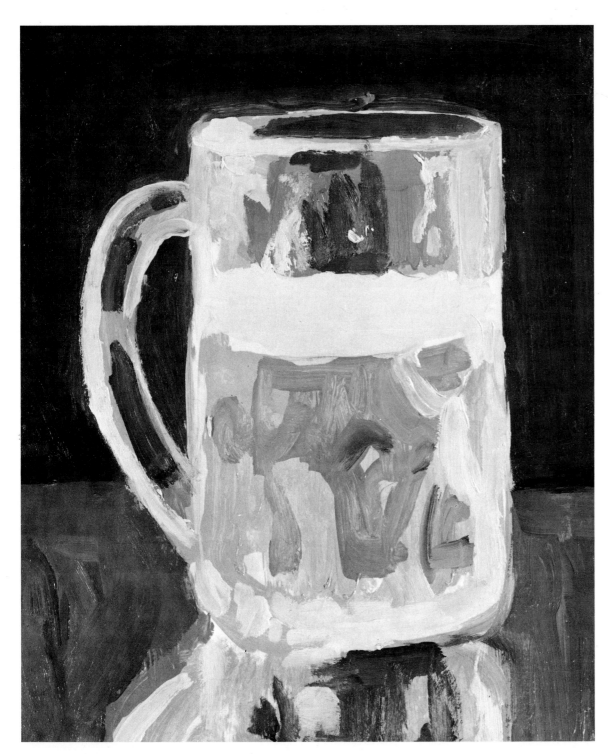

Beer: Step 2. Here I lay in tonal values where needed on top of what was painted in Step 1. I use Tone 2 for the dark areas in the lower portion of the mug where you see the beer, such as found in the center. I lay in Tone 0 on the right side for the large highlight, which will be highly irregular due to the indentations of the mug.

I use Tone 3 for the dark area in the center of the upper part of the mug. To the left and right of this, where the values are lighter, I use Tone 2. Tone 0 is applied for the strong highlight to the right, for the large amount of foam on the left, and the specks of foam near the center. The lip is Tone 0, and the oval area of the mug surrounded by the lip is Tone 3.

I use Tone 0 on both edges of the handle. The darkest inner values here are Tone 3, the lighter values are Tone 2. All the colors in the mug are roughly simulated in the reflection using the same values. I use Tone 2 for the tabletop and the background is Tone 3. The darker horizontal line of Tone 3 at the bottom is for atmosphere and represents the edge of a bar.

Beer: Step 3. I add ultramarine blue, underpainting white, cadmium yellow medium, and cadmium yellow light to my palette. For the beer in the mug, I use cadmium yellow medium for the dark areas in the center section. The dark spots in this area are raw umber lightly brushed into the yellow. I mix cadmium yellow light with underpainting white for the lightest yellow spots seen on the left. This is done thickly in order not to pick up the Tone 1. A combination of ultramarine blue, Tone 1, and white gives me the color for the highlights of the indentations on the right and for the bottom of the mug. The highlights in the mug and on the base are Tone 0. I also place a dab of raw umber in the right side of the base and accentuate the bottom edge with a long stroke of raw umber.

I gently blend the values in the handle and then brush in my pale blue color near the bottom. I also add this blue to the left side of the layer of foam in the mug and gradually blend it into the white. Above this foam, I again blend in my raw umber tones and then accentuate the foam on the glass with underpainting white.

For the mug opening, I blend the white of the rim into the Tone 3, letting my strokes follow the shape of this opening. I use the same colors in the reflection as I used in the mug, only in a sketchier manner.

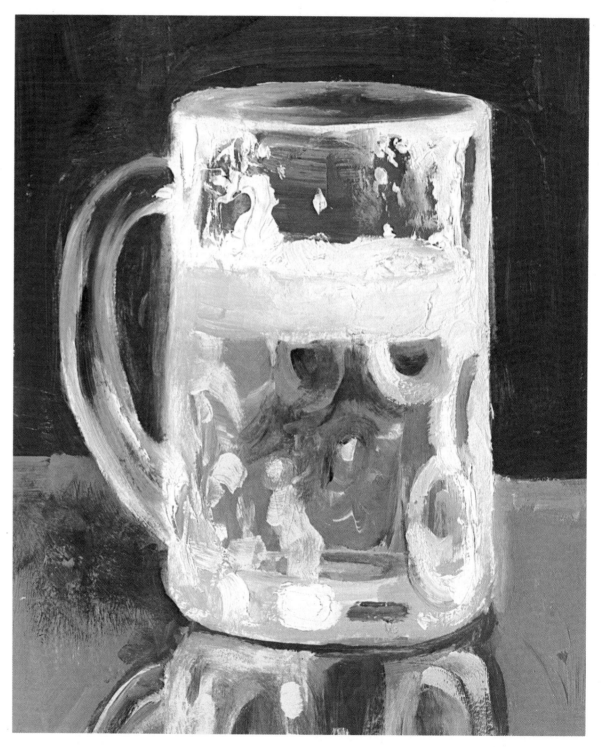

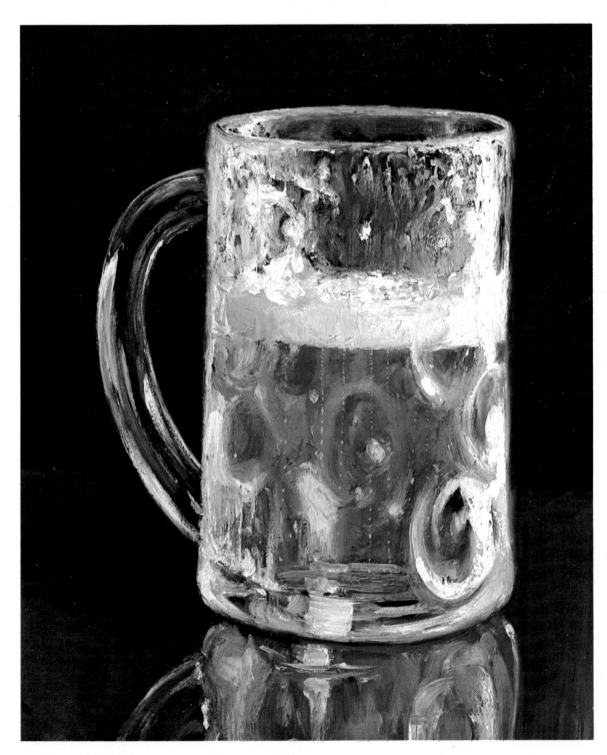

Beer: Step 4. I add burnt sienna, Mars yellow, and phthalo blue to my palette. In the beer-filled area all I do is blend the light yellow portions into the darker areas. The blue lines of the indentations are lightly blended and softened by brushing in some of the surrounding yellow. I emphasize the other mug indentations with cadmium yellow medium. I add a few dabs of cadmium yellow light and white for the center highlights and also apply it with a tiny brush for the bubbles in the beer.

I blend the colors in the bottom of the mug and darken this area where needed with ultramarine blue and raw umber. Raw umber is laid under the bottom of the mug for its shadow. The background is changed to a blackish color by combining ultramarine blue with raw umber. This color is also seen through the handle and upper portions of the mug. After brushing this into the handle, I casually add a streak of white and cadmium yellow medium along the sides. I brush in white over the background color at the top of the mug to indicate the rim and also redefine the foam and blend it slightly.

Mars yellow, burnt sienna, and phthalo blue are combined for the bar surface. I use slight variations of this on the left of the mug to indicate minor reflections. The streaks and reflections to the right are a mixture of yellow, burnt sienna, and white. The mug reflection is blended in the same manner as the mug.

DEMONSTRATION 19
CHINA

China is a very nice, cut-and-dried topic which offers variations only in shape and color. The shiny finish that is so typical of china doesn't vary due to the technical requirements of its production. It therefore seems preferable to understand the nature of china rather than go into the painting of the subject which is a simple wet into wet, or alla prima technique.

To begin with, china is a colloquial term applied to the category known as porcelain. One of the prime characteristics of porcelain is that the claylike material used to make it is pure white and any color can be applied over it. Not being an expert on the subject, I can only surmise that the method of applying color over a pure white surface is responsible for the clarity and sparkle of that color. Also, ordinary enamels are not used. Instead they use enamels that are derived from a glass base which might explain the richness of color and the glow they exhibit.

The final step of glazing is also specially controlled just for china, and the bond between the body and glaze has to be especially close. The glaze is formulated to expand and contract at the exact rate as the base, therefore eliminating any possibility of crackling with use and age. The finished product has a shinier and more perfect finish than any other form of pottery. It's resistant to abrasions and its surface has a highly reflective nature.

It's this purity of surface that you're most interested in when painting china. You'll find many highlights reflecting off this surface, but unlike other highly reflective substances, such as metal, china doesn't generally reflect surrounding colors. Its reflections tend to be white and sparkling, giving the impression that they're radiating from within and remain apparent even under low degrees of light. Once you've acquired the ability to render these all-important highlights accurately, you'll be able to paint a lovely piece of china.

China: Step 1. I begin work by drawing in the basic shape of the cup and saucer with thinned Tone 1. I want to render this accurately before adding the various tonal values. The surface I'm working on is pure white, so I let this represent the whitest portion of the cup. Therefore I only need to indicate the shadowed portion of the cup's interior on the left.

I use Tone 2 for the dark exterior of the cup. A streak of Tone 0 sweeps along the bottom of this area to show a reflection from the cup's base. The base of the cup is filled in with Tone 1 thinned with turpentine.

Tone 2 thinned with turpentine is what I use for the dark parts of the saucer on the far left and right. The light area in the right center is thinned Tone 1 and I surround the whole cup and saucer with this same wash.

China: Step 2. I fill in the inside of the cup, the handle, and the cup base with a combination of Tones 0 and 1. I add pure Tone 1 to the left shadowed side and blend it towards the center.

I now use Tone 2 to fill in the exterior surface of the cup and for the saucer, applying it more densely on the left and allowing it to thin out as I approach the center and the right side.

I use Tone 3 for the large cast shadow on the right side of the cup and saucer, and also for the dark shadow on the right side of the cup's exterior. For the reflection between this shadow and the handle I place a streak of Tone 1. I also see shadows on the left front edge of the saucer and under the edge of the base of the cup, and I use Tone 3 for these. I mix a background color by thinning Tone 1 with turpentine and paint this in.

China: Step 3. I add ultramarine blue, cobalt yellow, and yellow ochre to my palette. I mix raw umber, ultramarine blue, cobalt yellow, yellow ochre, and white in two ways to give me one light greenish tone and one dark greenish tone. These will simulate the color of the china.

I refine the color of the cup's interior, base, and handle, being careful that they remain off-white enough to permit bright highlights to be added later. With Tone 2 I brush in the shadows on the left side of the cup's interior, the far right side of the base, and on the left side of the handle where the cup casts a shadow.

I paint over the exterior of the cup and the saucer with the light green mixture. I use the dark mixture for the shadows on the left of the saucer, right side of the cup, and cast shadow on the saucer behind the handle. The shadow under the base of the cup, however, is a combination of raw umber and ultramarine blue. The large cast shadow on the table remains as is.

I use a combination of raw umber and yellow ochre for the gold bands. Next, using the corner of a flat 1/4" brush I highlight the bands with a combination of yellow ochre and white. I now come back over these highlighted areas with streaks of pure yellow.

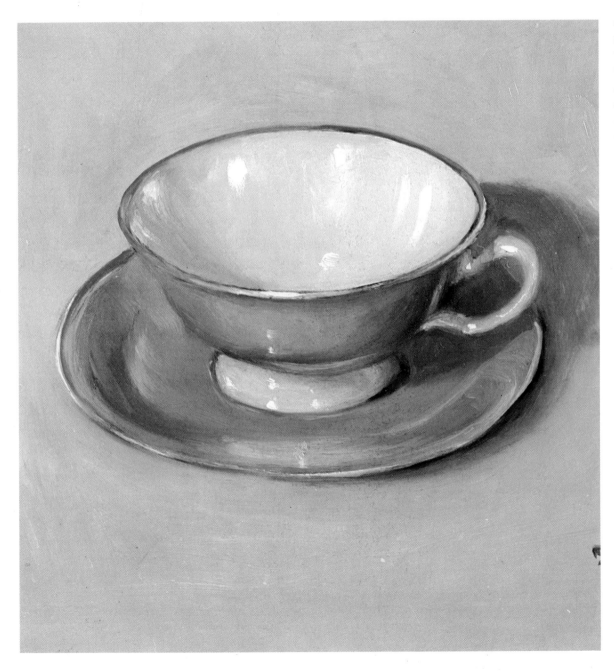

China: Step 4. Now I blend and smooth what has already been laid in. This includes *adding* variations wherever needed. For example, I highlight the lower center of the saucer by brushing in a streak of white.

On the cup exterior and the saucer, I lightly brush in a combination of raw umber and blue into the shadowed areas. The shadow underneath the right side of the saucer is raw umber.

For the highlights on the top of the handle and other light colored areas I use white. For the highlights in the shadows, I use Tone 2. I also use Tone 1 where needed on the cup and saucer.

I mix cobalt yellow and white to get a medium deep yellow color for use on the gold rims. In various places I use pure cobalt yellow to help create the gold look. The light highlights are a mixture of cobalt yellow and white. The background is Tone 1, and the large cast shadow on the right is gently blended into it.

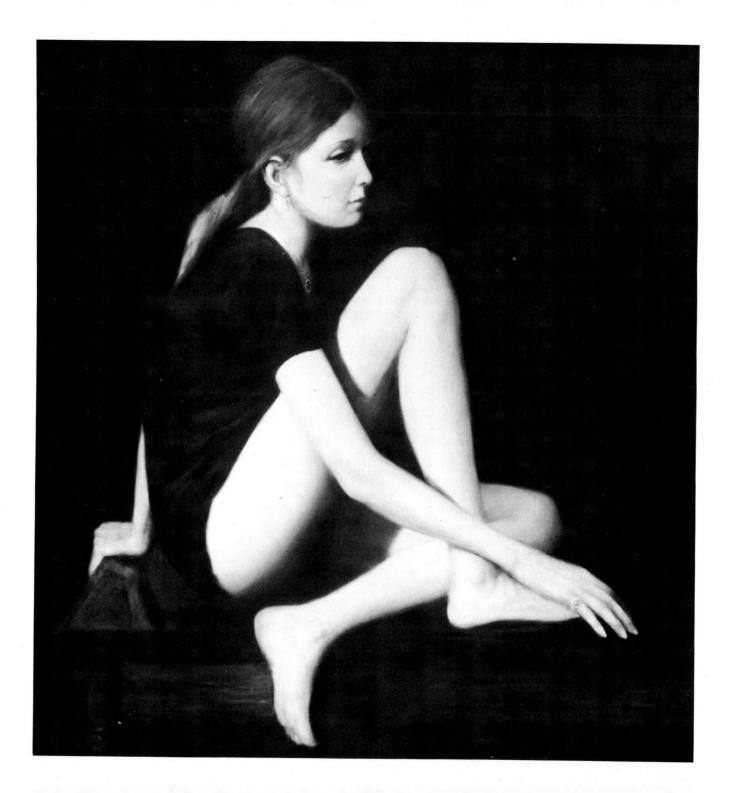

DEMONSTRATION 20
JEWELRY

Barefoot Ballerina, oil on Masonite, 24'' x 26''. Although the jewelry is but a small part of this painting, it's still important. The earring and chain were painted with Mars yellow and cadmium yellow light. The stones on the necklace and ring were painted with lapis lazuli to emulate the actual stones. Collection of the artist.

Painted jewelry can have an almost mystical quality. Done well, it seems to glow. Without a doubt, it's capable of making a strong impression on the viewer.

You may do well to guide your model in the selection of the pieces to be worn, due to the various effects jewelry can have. A large, ornate necklace loaded with stones will be overpowering on a delicate young girl. Conversely, a delicate locket would look silly on a stately matron. You don't want to sacrifice your painting for the sake of an interesting piece of jewelry.

The topic of jewelry is an extremely large and varied one. Even though metal is often used in jewelry, I chose to do this demonstration with pearls and diamonds, because the techniques for painting metal are similar to the ones for painting silver in Demonstration 3.

One reason I chose to use pearls is that I find them useful to create interest or to use for balance. They have a special softness about them that's always flattering and that will enhance almost any sitter. Pearls are greatly admired for their beauty; also, they can be combined well with a large variety of costumes, making them a versatile subject.

Technically, pearls must be painted very accurately or they'll appear as a series of flat white discs. You must carefully use your colors to capture the form and roundness of each pearl.

Diamonds, on the other hand, can be rendered more impressionistically. If you capture their brilliance and glitter, it's usually quite sufficient.

As you can tell, I'll be dealing with both the subtle and the flashing components found in so much jewelry. I find this an extremely interesting combination and one especially enjoyable to paint.

Jewelry: Step 1. First, let me explain that even though the first two steps of this demonstration appear in black and white, I'm really working with a basic skin color composed of a mixture of Venetian red, white, and yellow ochre. The reason I'm doing this is that pearls reflect skin tone, and I need this color as a guide for painting the various tonal values.

I begin with a 1/4" flat brush and Tone 2 to swirl in the basic round shape of each pearl. I try to portray their size accurately, noting that they become smaller as they approach the far left.

With a #2 watercolor brush and raw umber I lay in the shadow under each pearl and to indicate the clasp setting and its shadows. Again with a #2 watercolor brush, I apply a dot of white to each pearl for the highlight. Notice that the light hits each pearl uniformly. The background is raw umber.

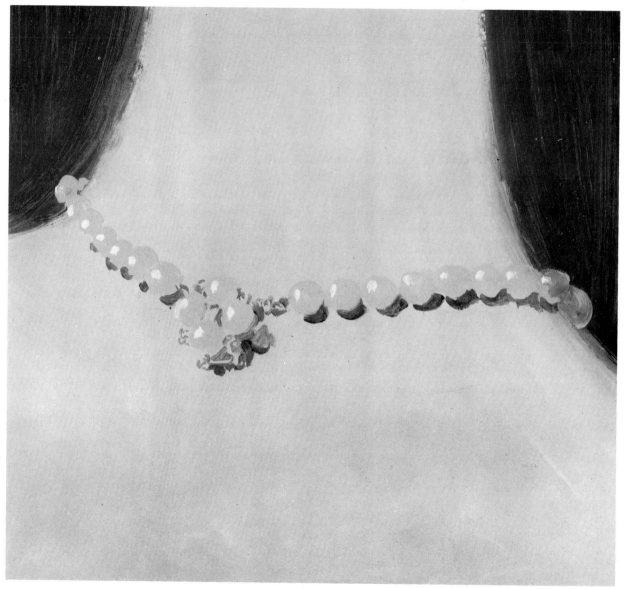

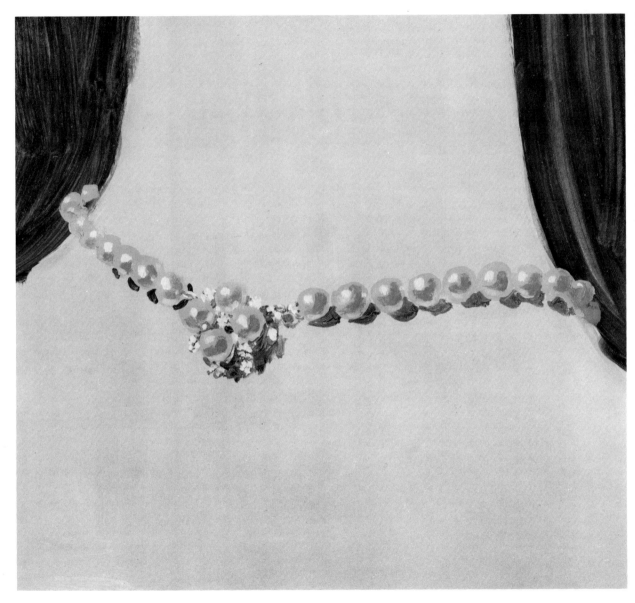

Jewelry: Step 2. I begin by thickly laying in dots of underpainting white for the diamond clusters in the clasp with a ≠ 2 watercolor brush. I notice that some pearls — like the one next to the clasp on the left — pick up a secondary highlight from their neighboring pearls. I lightly dab in a dot of white wherever I see this, but it won't be found on all the pearls.

Since the light comes from the left, the shadowed portion of each pearl is on its right side. I use Tone 3 for this shadow, being careful not to apply it to the edge of the pearl. To further give shape to the pearls, I lay in Tone 1 along their bottom edges, following the rounded shape with my brush as I do so.

Jewelry: Step 3. As I mentioned in Step 1, pearls reflect the tones of the skin. I therefore lightly blend my skin tone color (Venetian red, yellow ochre, and white) into each pearl. I feel that all the other tones I've added to the pearls thus far have darkened them too much, so I blend white lightly into each one. As I do this, I automatically blend the other tones together. This has a twofold purpose: it lightens the color and it adds translucence. I find this far more satisfactory than trying to maintain whiteness from the beginning.

I add ultramarine blue to my palette and brush it very sparingly into the shadowed portions on each of the pearls. Venetian red and white are brushed lightly into the raw umber shadows cast underneath the pearls. After doing this, I soften the edges of all the cast shadows. I blend all the colors in each pearl to create a high degree of softness, and the pearls are finished.

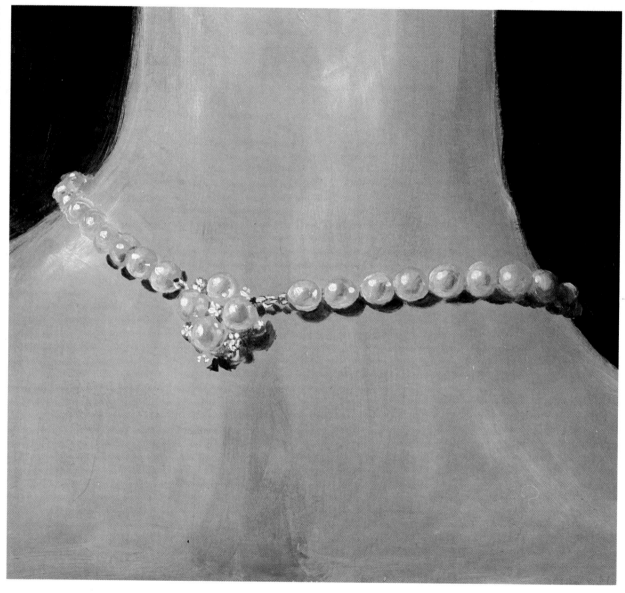

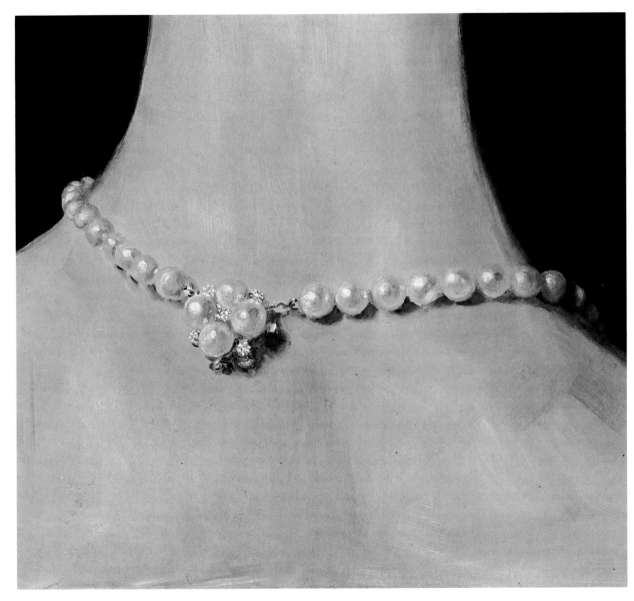

Jewelry: Step 4. I allow Step 3 to become completely dry and then cover the entire painting with painting medium.

I take ultramarine blue and raw umber and thinly glaze over the tops of the diamonds. I then allow this to sit for 20 minutes. After that, I take a brush dipped in painting medium and go over each diamond. This removes the glaze I have just applied, leaving a vague tint of color. Now I take a #2 watercolor brush and place a thick dab of underpainting white in the location of each diamond. I complete the painting by further softening the cast shadows under the pearls and clasp.

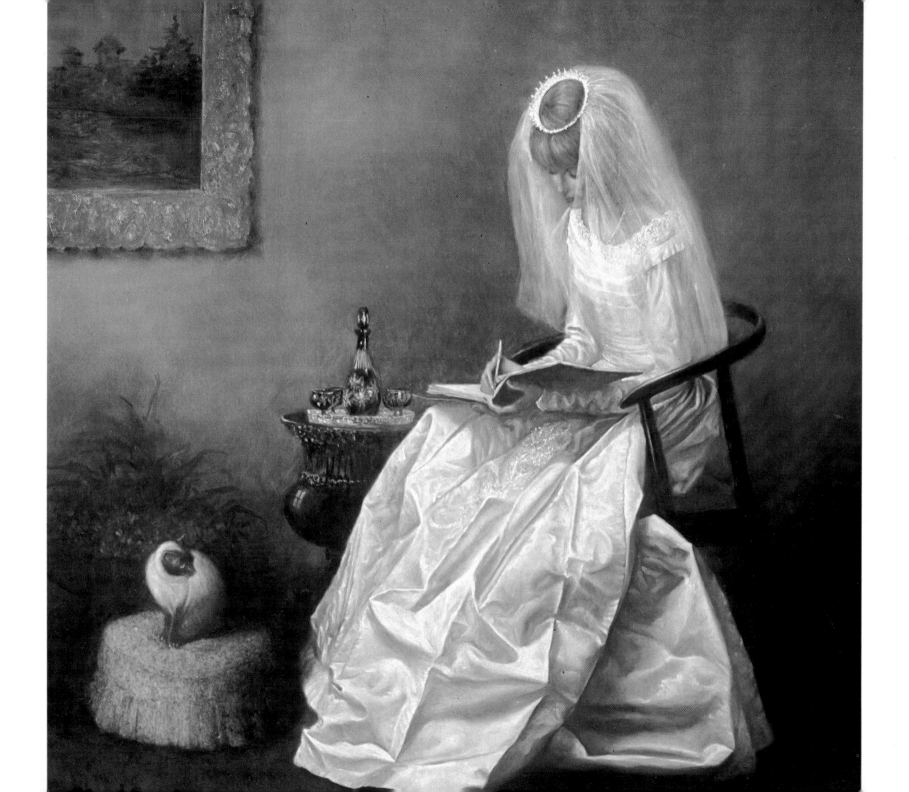

SUGGESTED READING

Blake, Wendon, *Creative Color: A Practical Guide for Oil Painters*
New York, Watson-Guptill Publications, 1972. London, Pitman Publishing, 1972.

Cooke, Lester H., *Painting Techniques of the Masters*
New York, Watson-Guptill Publications, 1972. London, Pitman Publishing, 1973.

Dawley, Joseph, *Character Studies in Oil*
New York, Watson-Guptill Publications, 1972. London, Pitman Publishing, 1973.

Doerner, Max, *Materials of the Artist*
New York, Harcourt Brace Jovanovitch, Inc., 1949. London, Hart-Davis, 1969.

Henri, Robert, *The Art Spirit*
New York, Keystone Books (J. B. Lippincott Co.), 1960.

Massey, Robert, *Formulas for Painters*
New York, Watson-Guptill Publications, 1967. London, Batsford, 1968.

Mayer, Ralph, *Artist's Handbook of Materials and Techniques*
New York, Viking Press, 1970. London, Faber and Faber, 1964.

Taubes, Frederic, *The Painter's Dictionary of Materials and Methods*
New York, Watson-Guptill Publications, 1971.

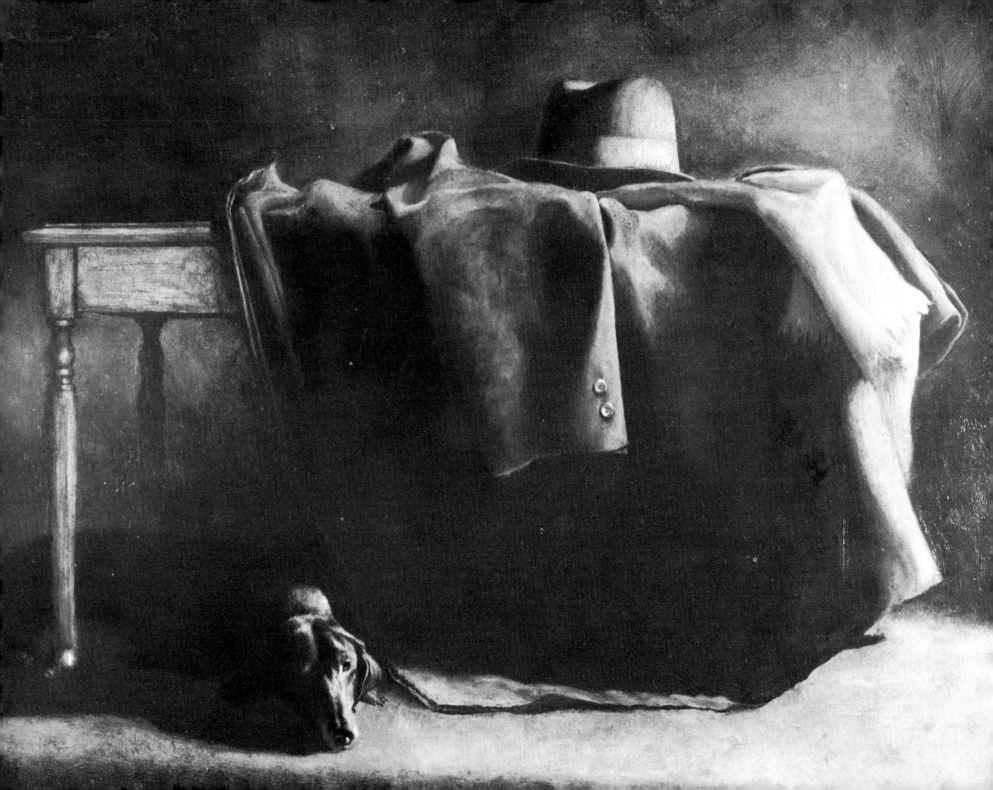

INDEX

Waiting for the Master, oil on Masonite, 15" x 20". This painting is a good example of dull, smooth fabrics. I find the impasto technique used here best for this type of rendering. Collection Mr. and Mrs. Morton Goldman.

Girl with Red Ribbon, oil on Masonite, 15-1/2″ x 12-1/2″. The bright red ribbon in the model's hair and the duller red drape set off the skin tones in the same manner as the fabric in Demonstration 4. Collection Mr. and Mrs. Harold Holberg.